DRAWING
MANGA
People and Poses

Contents

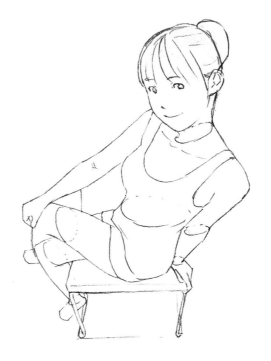

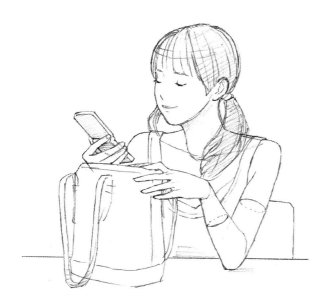

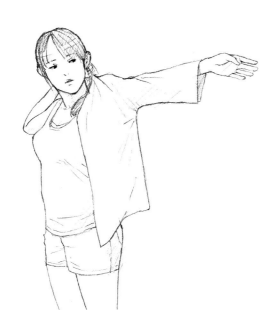

CHAPTER 3

Around the House 91

CHAPTER 4

At Work & At Play 127

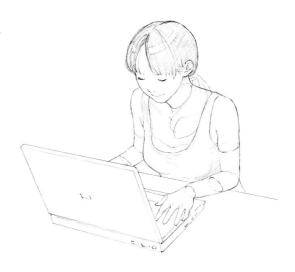

Chapter 1

Drawing Basics for People & Objects

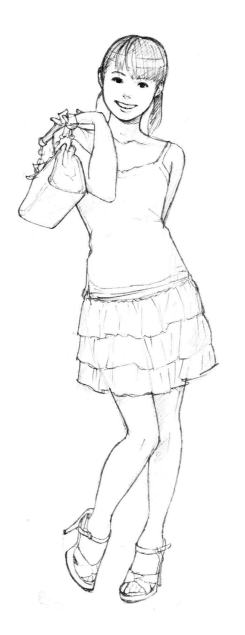

One of the best ways to learn how to draw realistic characters is to practice drawing people from life or from a photograph. Drawing standing figures at rest is quite different from sketching them in action. As soon as characters start to move and interact with the world around them, they can quickly become unnatural and awkward in appearance. This can be quite a challenge to overcome, especially for a new artist. This chapter explains the basics of drawing natural and balanced characters in a variety of poses.

1.1 *Drawing from Reference*

Drawing from life, referencing photos and copying others' illustrations are all essential training techniques for an artist. Here's a great method for breaking down images into easy-to-draw shapes. Follow these basic guidelines and you'll be able to capture the form and composition of any image in front of you.

Let's give it a shot! First, copy the simple free-form shape on the left without tracing it. You might find this to be surprisingly difficult on your first try.

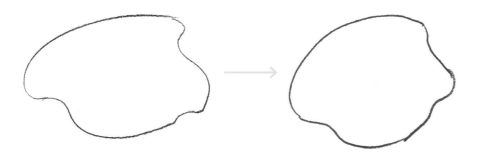

It's not working.

Try it again. This time, follow these key points:

- Replace the object with simpler shapes
- Measure the object with parallel and perpendicular lines
- Mimic silhouette and proportion rather than detail

01 Find each location where the shape changes dramatically, and mark it with a point. Then connect each point with a line.

02 Now copy out this new angular shape.

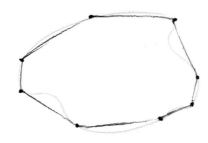

Tip: Keep checking the angle of the lines against those of the original. Sketch in horizontal or vertical lines to help you measure.

06 The drawing is complete. It's important to compare your final drawing to the original photo, but make sure you feel that it's working by itself too.

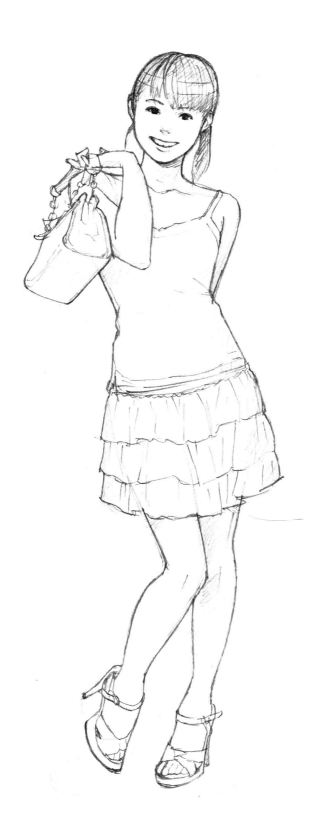

Variations

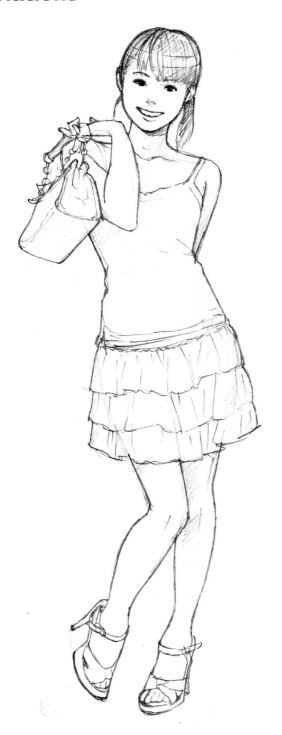

Original drawing from page 15.

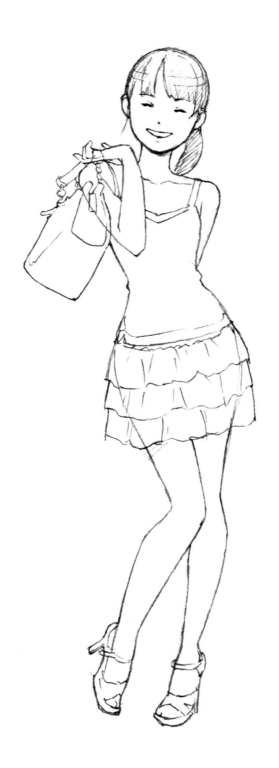

Here's a more cartoony version of the sketch. Her general proportions remain the same, but her design has been streamlined.

Experimenting with Eye Level

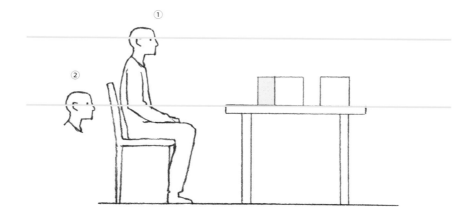

● The view from directly above the table

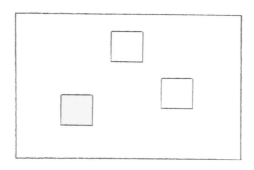

● The view from eye level ①

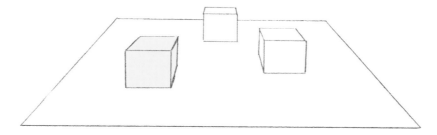

● The view from eye level ②

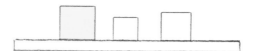

Low Angles vs. High Angles

Let's take a look at a seated posture from both above and below eye level. Imagining a box around your subject can make it much easier to grasp the perspective of the shot.

Low angle

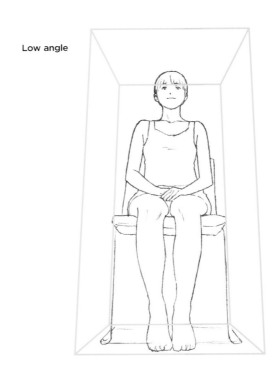

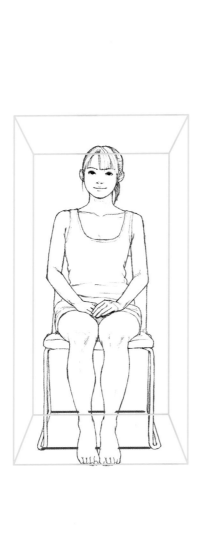

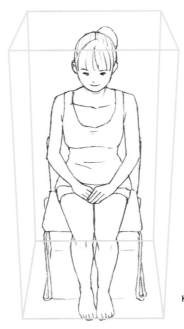

High angle

For an extra challenge, add crossed legs into the pose. Just break the body up into different shapes and use construction lines. Keep the full volume of each section of her leg in mind as you determine the legs' relationship in space to each other.

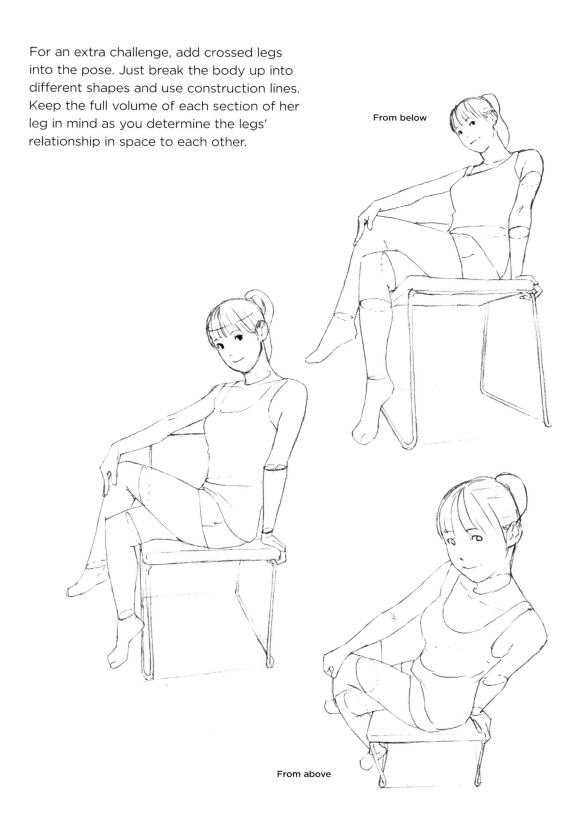

From below

From above

1.4 Constructing Objects

Drawing Lines

Sometimes, drawing straight lines can feel absolutely impossible! But with a bit of technique and practice, you'll be drawing wonderfully clear lines before you know it.

Tips:

- Hold your pencil lightly: You can't draw straight lines if your hand is clenched around your drawing tool. Relax and let the tip of your pencil glide across the paper.
- Be mindful of where each line starts and ends: Knowing that you're traveling from point A to point B lets you concentrate on the line itself.
- Turn the paper so your hand is always in a comfortable position.

This can take a lot of practice, so let's jump right in and get drawing.

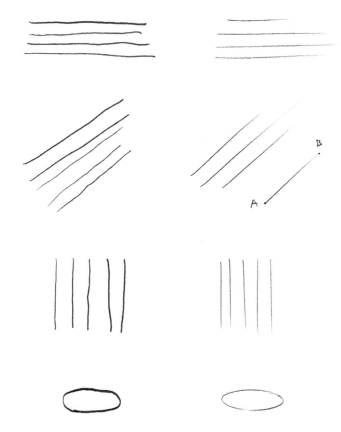

Segmentation

How to Bisect

Draw two diagonal lines connecting the inside corners of the square. Then draw a vertical line through their point of intersection (A). Now you've perfectly bisected the square.

A Finished View

 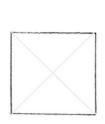 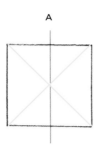

How to Trisect

Repeat the bisecting process shown above. Then draw two more diagonal lines connecting the inside corners of those two new rectangles inside the bisected square (A). Draw two more vertical lines through these new points of intersection (B) and finish.

A B B Finished View

 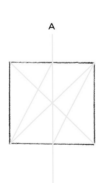 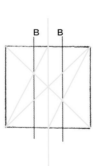

Segmentation in Perspective

You can use this same method to divide up an object in perspective as well. You can always find the center of a square this way, no matter what the angle.

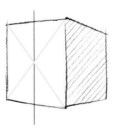 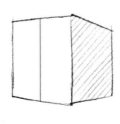 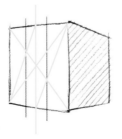

Simplify Complex Forms into Basic Shapes

It's quite difficult to jump right into drawing a complex object. Instead, break the object down into its most basic forms—think cylinders and cubes—and pay attention to where they intersect.

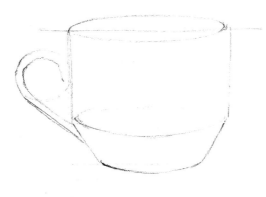

This curvy cup is actually a simple cylinder with a few additions.

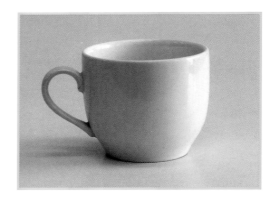

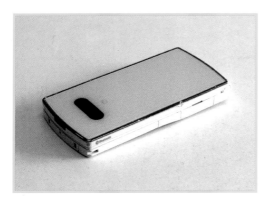

To draw a rigid shape like this cell phone, rough it out first with straight lines. Then erase and edit your lines to capture the gentle curves of its design.

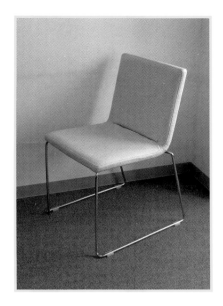

This chair is basically just a cube with some added squares.

You can break this handbag down into a triangular prism with a handle on top.

An open umbrella starts with a circle of spokes.

Line Drawings vs. Shading

When it comes to line drawings, an object with lots of small, thin, white-on-white details usually calls for measuring and drawing each component individually. But if you're using watercolors or digital shading instead of pencils and pens, you can make your life a lot easier by using strong contrast to suggest the overall shapes.

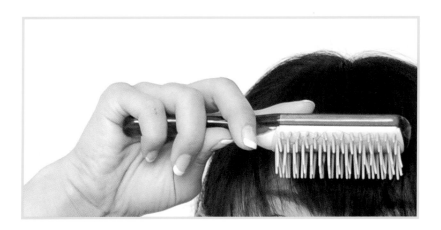

When coloring, start out by shading in the darkest values of the object with a big brush. Then come back in with a thin white pen and add the bristles back on top.

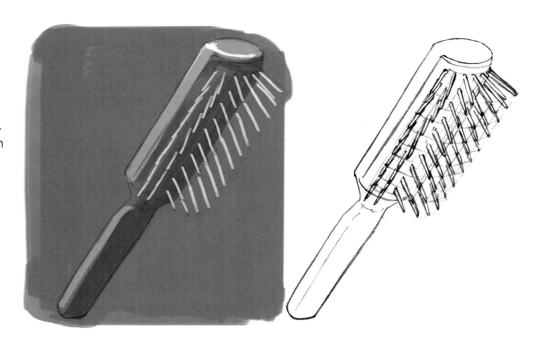

Level of Detail

Out in the world, the farther away something is from us, the less we see. For clear and lifelike illustrations, adjust the amount of detail you draw depending on the distance between the viewer and the subject. You may be tempted to load on the details for both close-ups and far away shots, but moderation can bring realism to your drawings.

Close-Up

Far Away

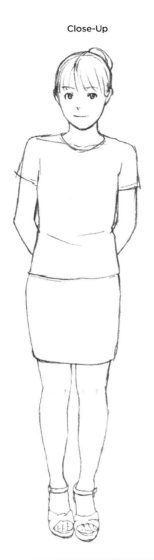
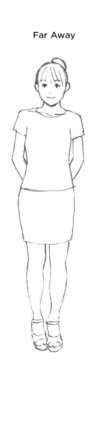

These drawings show the same person wearing the same clothing. However, much more detail is visible in the close-up drawing, including the strands of her hair, the wrinkles of her clothes and the details of her shoes and feet.

Compare at the Same Size

Here is a comparison of her feet with the smaller drawing enlarged to match the size of the original. Can you see how each line has been simplified and streamlined?

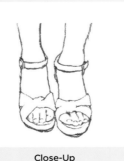

Close-Up

Far Away

1.5 Relationships Between People & Objects

Soft and hard objects each hold their own unique properties.

- **Soft objects:** Change shape (also known as '"squashing" or "stretching" in animation) when you apply force.
- **Hard objects:** Remain unchanged when held, but deform the soft flesh of your hand.

If you never explore the elastic properties of soft forms, your drawing will look stiff and unreal. Bring naturalism and balance to your art by paying close attention to how hard objects deform soft ones.

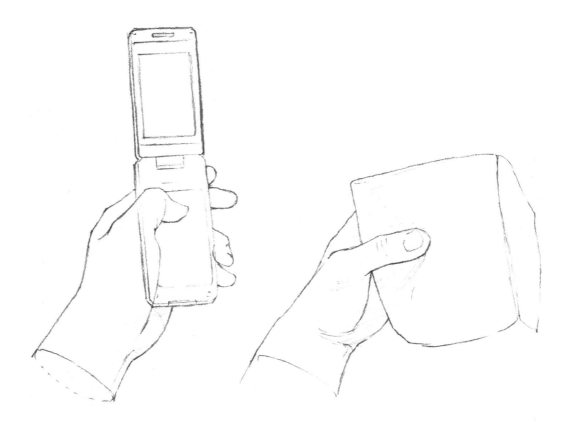

● Drawing Through the Form

Don't just draw what you see! Make sure to visualize the entire form of each object where it's hidden behind the hand.

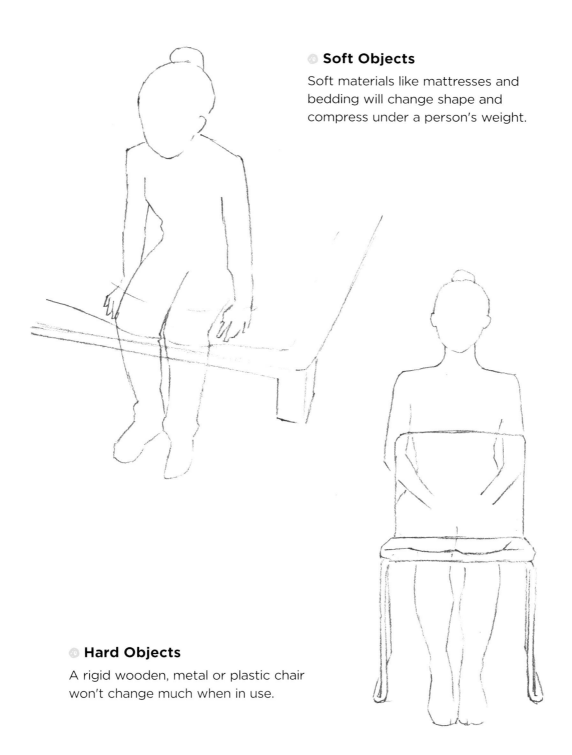

Soft Objects

Soft materials like mattresses and bedding will change shape and compress under a person's weight.

Hard Objects

A rigid wooden, metal or plastic chair won't change much when in use.

Let's put everything you've learned to use with the following exercise: Draw a person sitting on a chair.

01 First, draw a chair in perspective. Sketch lightly, so you can later erase the parts of the chair that will be hidden by the body.

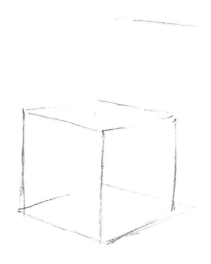

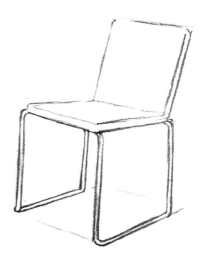

02 Mark the basic position of your sitter. Start with the major landmarks, like the shoulders, knees, hips and the bottom of the feet. Lightly connect your lines.

03 After you've blocked in the simple character framework (don't forget that midline!), it's time to start sketching the body.

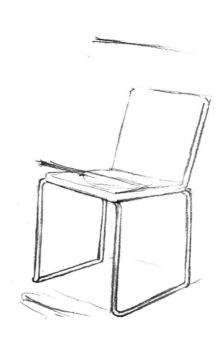

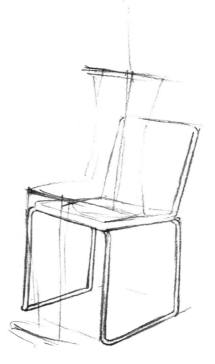

04 As you draw, pay attention to the 3-D forms of the body, and the volume and roundness of each limb.

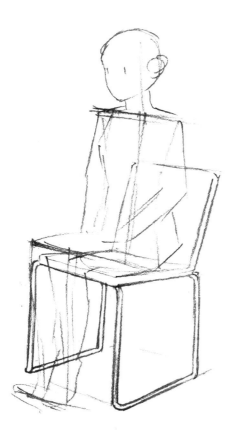

05 As you add in the finishing details, don't forget to pause and decide for yourself if your drawing looks "right." Following instructions to the letter won't always deliver a good image. The best way to improve as an artist is to boldly redraw whatever looks unnatural to your eyes.

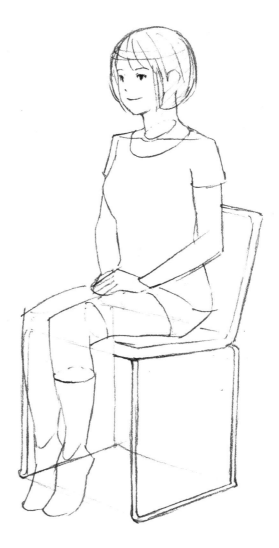

You can draw anything if you take the time to study it and understand its basic characteristics. Just remember—you have to decide for yourself if it's worth your time and effort for any particular drawing. You can always just swap out a different object if one is giving you too much trouble.

Drawing from Reference

Q: In this book, you draw illustrations depicting the relationship between objects and characters based on photos. Are there any points to keep in mind when working from a photograph?

A: Photos flatten 3-D reality into a 2-D image and they don't have the same depth of field. So when you base an illustration on a photo, it's important to be able to read depth and three-dimensional shape into that flattened image. Always keep in mind which parts of the image are closest or farthest away from the camera. By emphasizing these parts in your drawing, you can create much more depth than in the original photo.

Q: How do you determine depth when drawing a face?

A: For a start, when you look straight on at a person's face, their nose is the closest facial feature to you and their ears are the farthest away. It may seem like noses and ears don't have much difference in distance from the front, but they actually have about 4" (10 cm) of a difference between their positions. If you ignore this fact as you draw, the nose and ears will look like they're on the same plane.

Q: What techniques do you use to show depth in your drawings?

A: You can effectively portray the relationship between a close object and a far away object with a bit of contrasting brightness and shade. When you want to show the difference in distance between two objects, you emphasize the closest object by casting it in high contrast.

Q: So I have to look very carefully at the information in the original photo, right?

A: Yes, once you're aware of which object is in the foreground of the photo, you'll know where to bring strength to your line drawing. Draw those objects with a harder, thicker line. If the light in the photo comes from an overhead source, use a

thicker line at the bottom of each shape to suggest shade. Just changing one line can bring your drawing into three dimensions instead of two.

Q: I see. It comes down to the position of the objects and the direction of the light. Are you always conscious of the light source as you work?

A: Yes, because you can't figure out where to place the shadows if you haven't identified the light source. So verifying the direction of the light is important. Light rarely comes from one single source. For example, most of the photos in the book are lit with several fluorescent lamps. For your drawing, decide where the main source is and then determine the angle of the light. By looking closely at light in a photo, you can find the shadows. Emphasizing these shadows will bring depth and volume to your drawing.

Q: Do you draw highlights?

A: Yes. It depends on the surface material, but generally the lightest point of an object is the closest to the light source, and it darkens as the angle of the object changes. It's also good to draw reflected light too. For example, a cup on a table will have light reflecting off the table's surface back onto its base.

Q: Are there any other helpful points to keep in mind when drawing from a photo?

A: Keep in mind the angle and perspective from which the photograph was taken. Think about the position of the photographer in relation to their subject and what kind of lens they used, such as wide-angle or telephoto. Consider whether the photo was taken straight on at eye level, or from a high or low angle. These are essential points to address for a successful three-dimensional drawing.

Chapter 2

Everyday Life

In this chapter, we'll be drawing characters out and about and interacting with a variety of objects. It can be quite tricky to nail these slice-of-life poses in your own comics, but the key is practice and observation. Let's start by studying some actual photos of models as we draw.

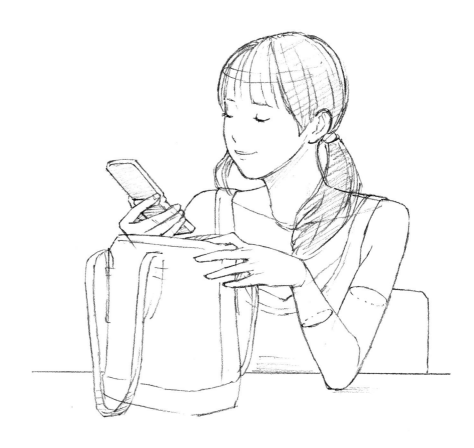

2.1 *Talking on a Cell Phone*

How does a person's posture change when they talk on a cell phone? Take a closer look at people taking calls on the street, in school or at the office and bring your observations into your sketches.

Before you start these poses, try sketching some quick cell phones from different angles. Then they'll be much easier to draw accurately, even when they're covered up by her hand.

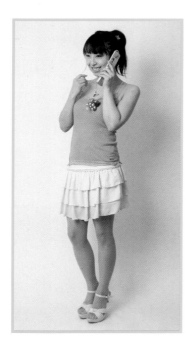

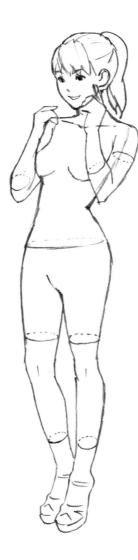

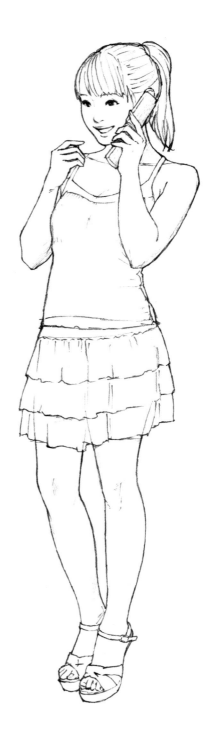

Let's give her a table to support her bag while she searches inside for her phone. She's resting her left elbow on the tabletop as she holds the bag open with her hand.

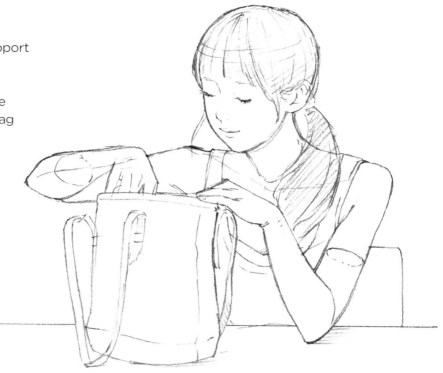

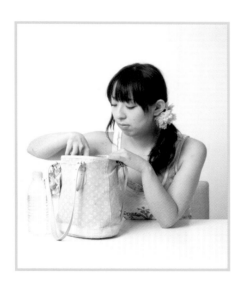

Now she's looking at the cell phone she just pulled out of her bag. Notice the subtle change in the direction of her lowered eyes compared to the picture above.

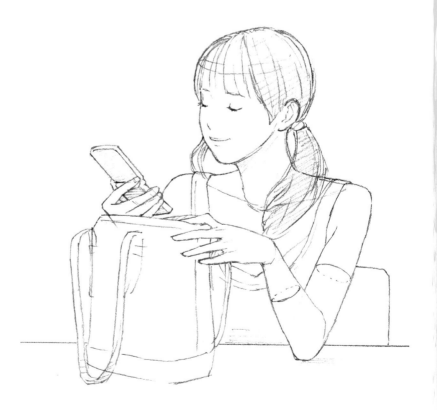

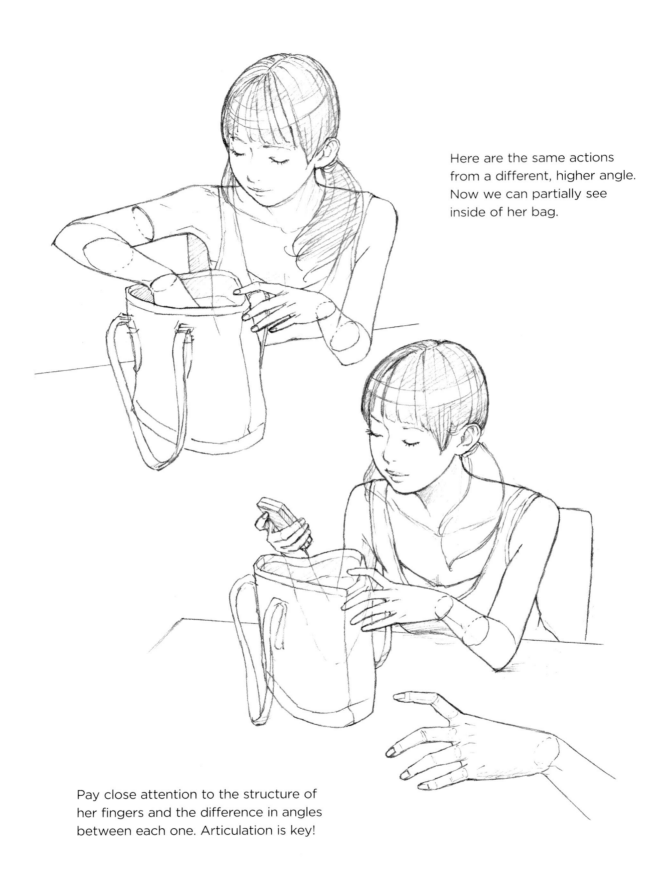

Here are the same actions from a different, higher angle. Now we can partially see inside of her bag.

Pay close attention to the structure of her fingers and the difference in angles between each one. Articulation is key!

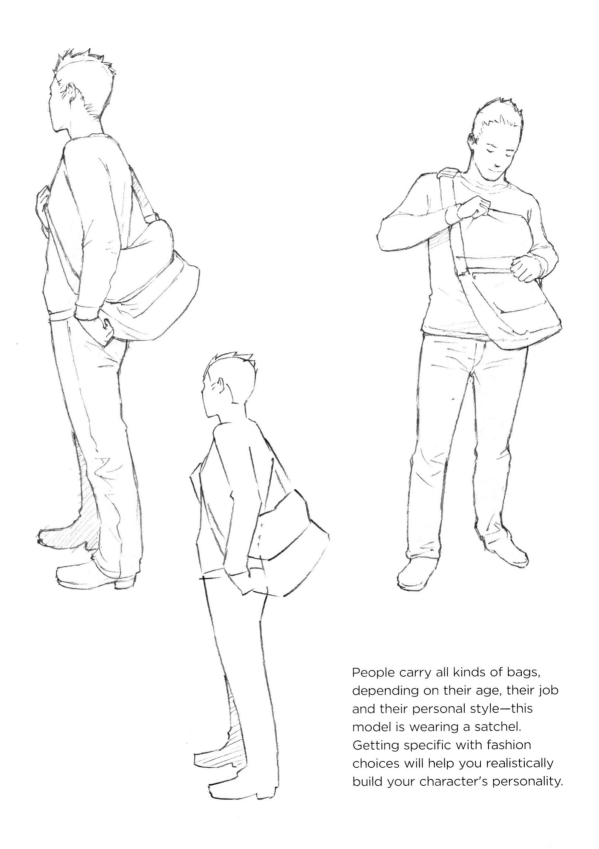

People carry all kinds of bags, depending on their age, their job and their personal style—this model is wearing a satchel. Getting specific with fashion choices will help you realistically build your character's personality.

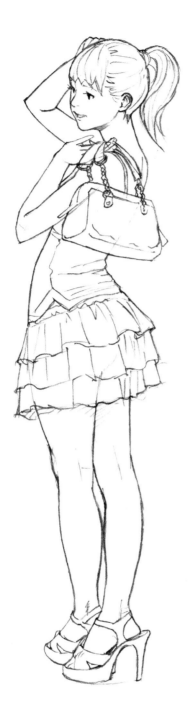

Casual poses are rarely rigid or symmetrical, so follow the flow from head to toe. This particular pose has several challenging elements, so let's break them down and resolve them one at a time. First off, we're viewing our model from behind as she hangs her purse over her shoulder. She's also twisting her torso to the left and arching her back. Finally, watch out for those crossed legs!

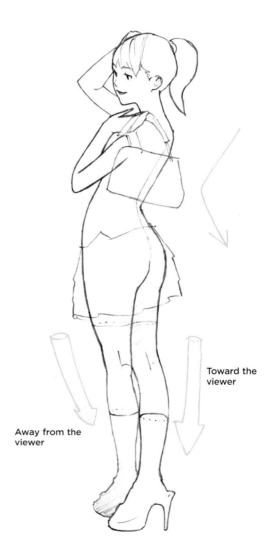

Toward the viewer

Away from the viewer

Pay attention to which leg is tucked behind the other and how far away her feet are from each other.

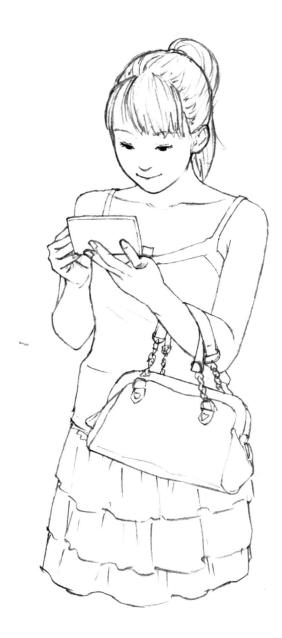

Between the mirror, the makeup and the purse, there's a lot going on in this pose! Call on reference photos and similar illustrations for help, or try the pose out for yourself to help understand all of the different elements at work.

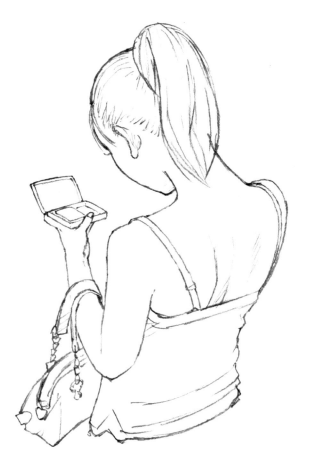

If you're continually struggling to draw this pose, it helps to look at it with fresh eyes. Rotating the page or flipping the image can reveal any imbalances in the composition. If all else fails, try walking away from your drawing for a while!

Wearing a Hat

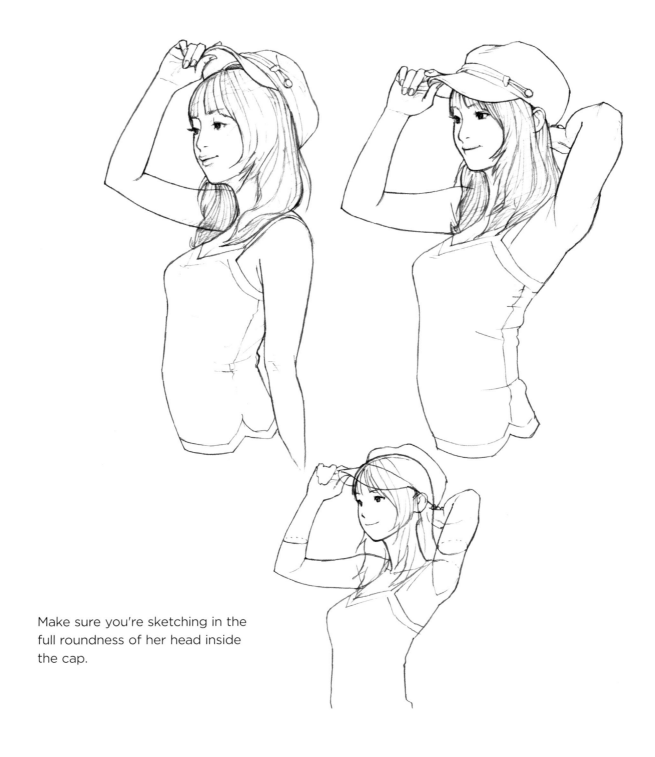

Make sure you're sketching in the full roundness of her head inside the cap.

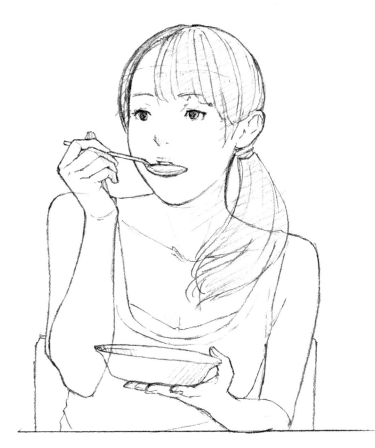

Always imagine the emotional and situational context of a pose as you work, even if it's just for one drawing. Practice and observe those around you to learn how people eat when they're in a rush, when they've just come home exhausted from work or when they're enjoying a meal out on the town with a close friend.

Rough in the silhouette of the hand first.

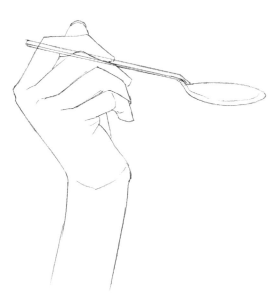

Don't forget to draw the full shape of the spoon as you draw the positions of the individual fingers.

Suiting Up

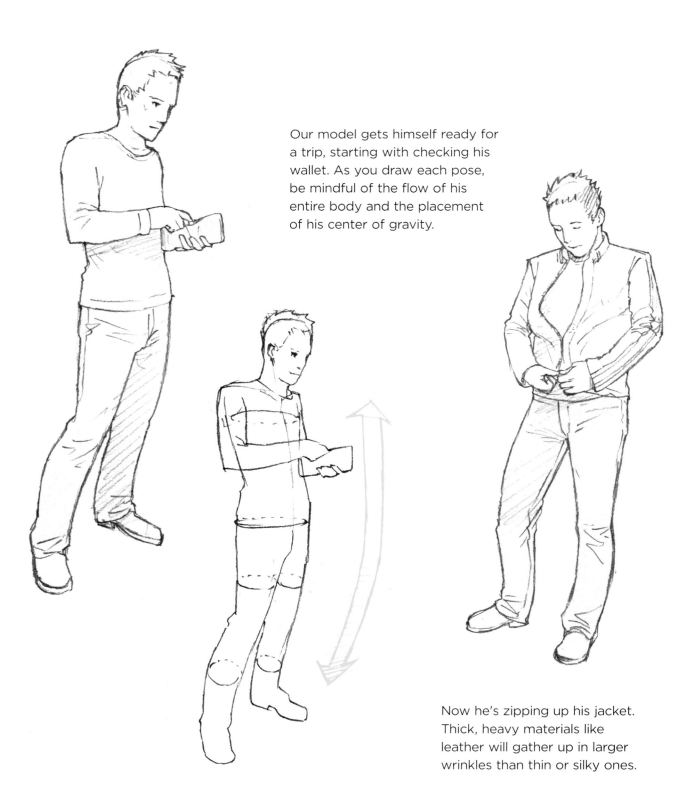

Our model gets himself ready for a trip, starting with checking his wallet. As you draw each pose, be mindful of the flow of his entire body and the placement of his center of gravity.

Now he's zipping up his jacket. Thick, heavy materials like leather will gather up in larger wrinkles than thin or silky ones.

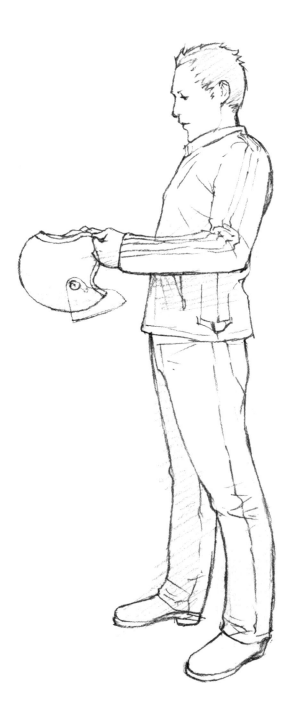

Time for a ride! Putting on a helmet usually involves several steps—placing it on the head, adjusting the fit, fastening the chin strap, lowering the visor, etc. Explore different moments for greater realism in your poses.

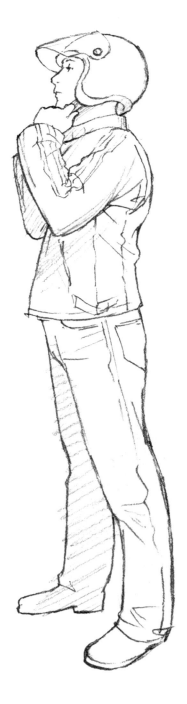

Riding Vehicles

How many times a day do you see cars and motorcycles? And how many people do you know who drive them? When you're drawing such familiar vehicles, make sure you've done enough basic research to satisfy your audience. You don't need to be an expert, but just understanding how to break vehicles down into wheels, frames, engines and seats will help you create believable illustrations.

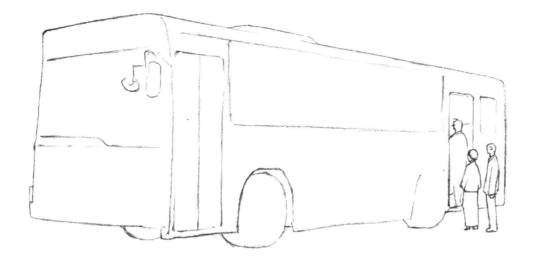

A line of passengers board a public bus. Notice the height of the wheels compared to the passengers and how high the doors are off the ground.

If your character drives, consider the type of vehicle they use. Different vehicles can represent a character's personality, age and income level, so do a little research to find the best model to match their background.

Let's take a ride on a motorized scooter! She's standing here with one leg on the ground to balance the stopped scooter, but she'll sit down as she fires it up. These kinds of vehicles are also very customizable to a character's personality.

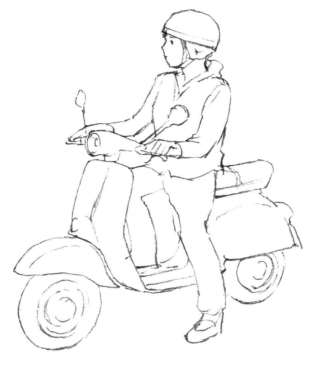

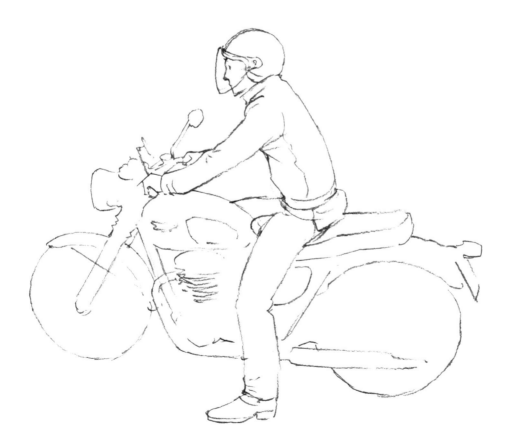

Everyday Life: Reference Guide for Drawing Hands

A well-drawn pair of hands can serve as the finishing touch which brings your whole illustration to life. This section includes all sorts of poses so you can easily reference them as you draw.

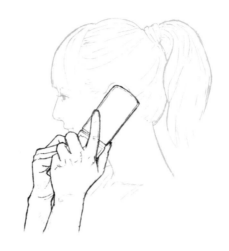
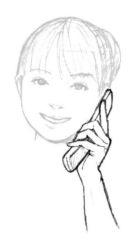

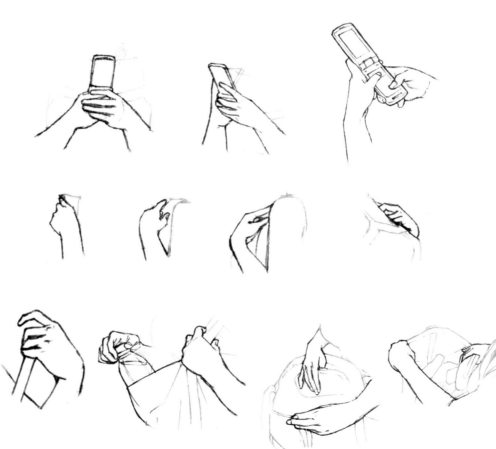

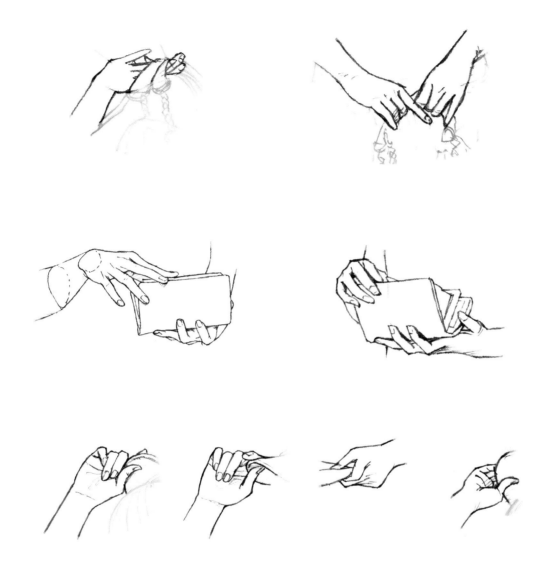

Practice sketching hands in every kind of action and angle you can imagine. The positions and forms are endless! By studying anatomical references and people in motion, you'll grow to understand how the underlying shapes of the wrist, palm and fingers shift and change depending on their actions.

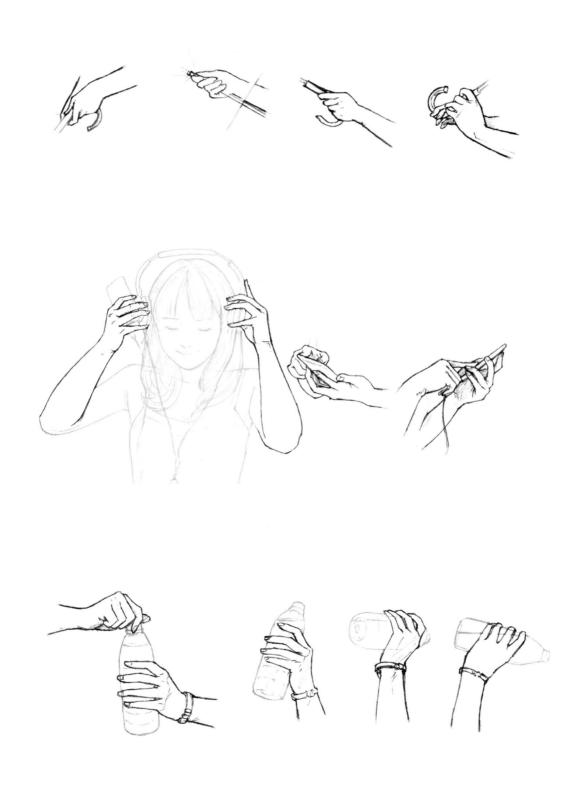

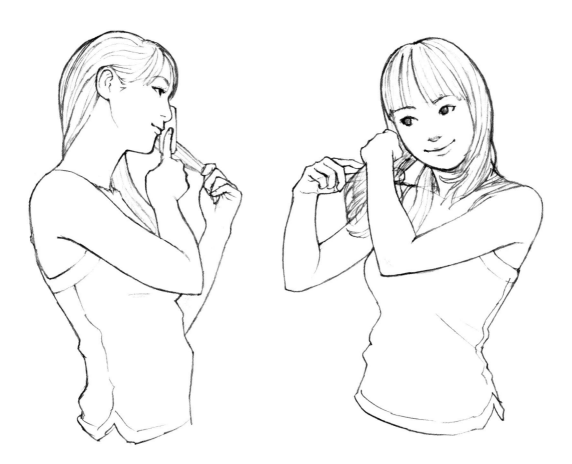

The same basic pose from different angles: Notice how the shift in our vantage point changes how we draw that tilt to her head and torso.

Start your drawing by sketching in her body and arms, making sure you understand what will be hidden by her hair. Here, we've shown the shape of her upper arm and shoulder behind her hair and forearm.

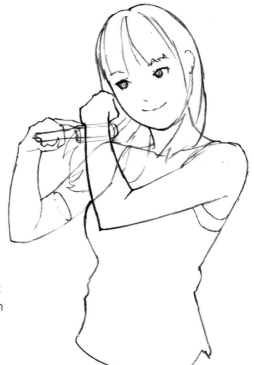

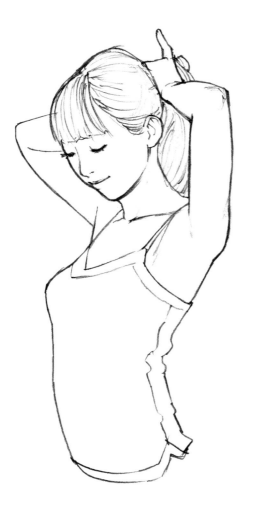

Match Detail to the Size of Your Drawing

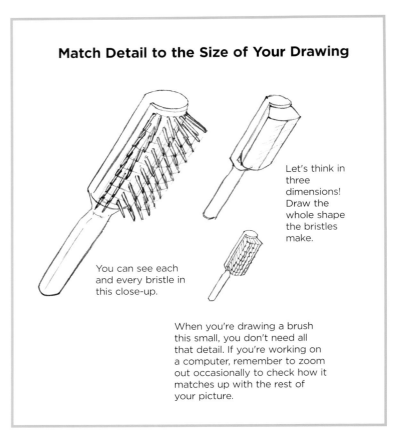

Let's think in three dimensions! Draw the whole shape the bristles make.

You can see each and every bristle in this close-up.

When you're drawing a brush this small, you don't need all that detail. If you're working on a computer, remember to zoom out occasionally to check how it matches up with the rest of your picture.

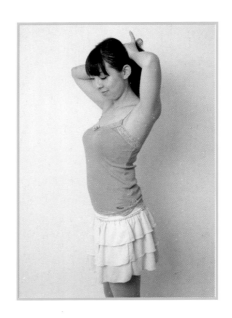

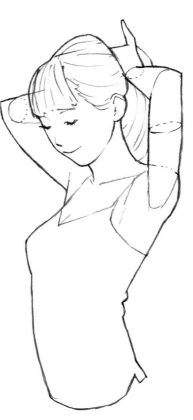

It's much easier to draw three-dimensionally if you visualize her arms as cylinders. Pay attention to the direction in which they point by lightly sketching in those little circles.

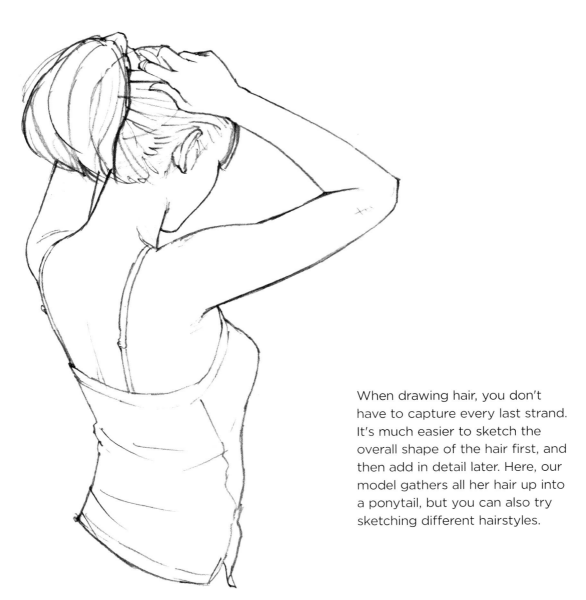

When drawing hair, you don't have to capture every last strand. It's much easier to sketch the overall shape of the hair first, and then add in detail later. Here, our model gathers all her hair up into a ponytail, but you can also try sketching different hairstyles.

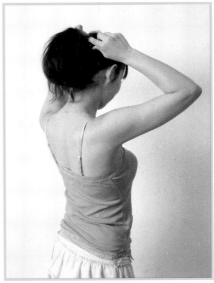

Putting on Shoes

Since this is such a difficult pose to capture, try sketching her silhouette first. Flattening out the image that way can help you make sense of the basic forms.

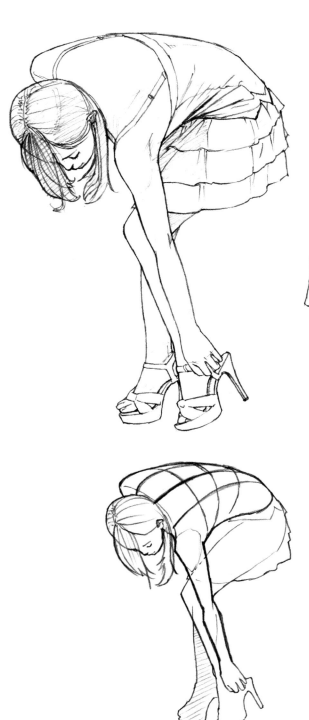

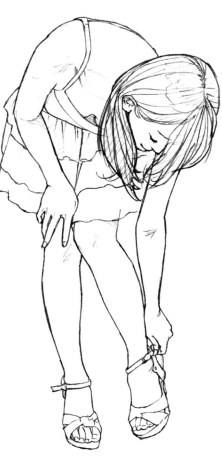

Pay attention to how her back curves forward as she reaches down.

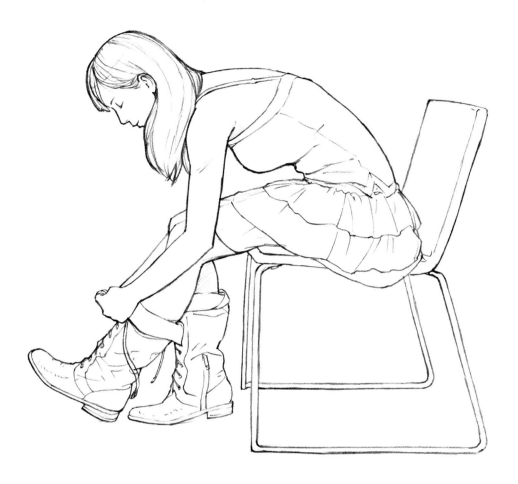

She's leaning forward to tie up her laces. Notice how she lifts her leg up to reach them more easily and how her hair hangs down over her shoulder as she tilts her head forward.

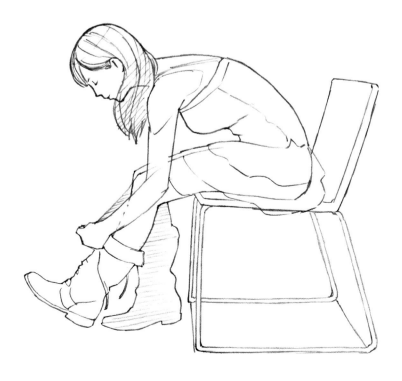

Vacuuming

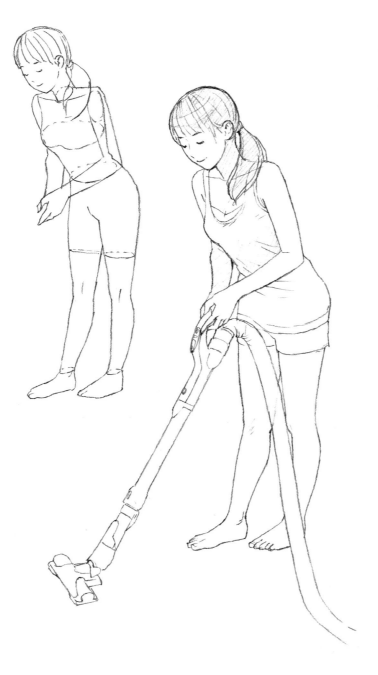

Our model vacuums with a long-handled attachment. Pay close attention to the direction of her line of sight—she's watching to make sure that the vacuum sucks up every last bit of dirt from the floor.

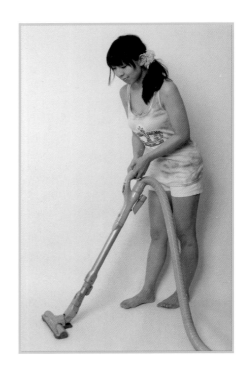

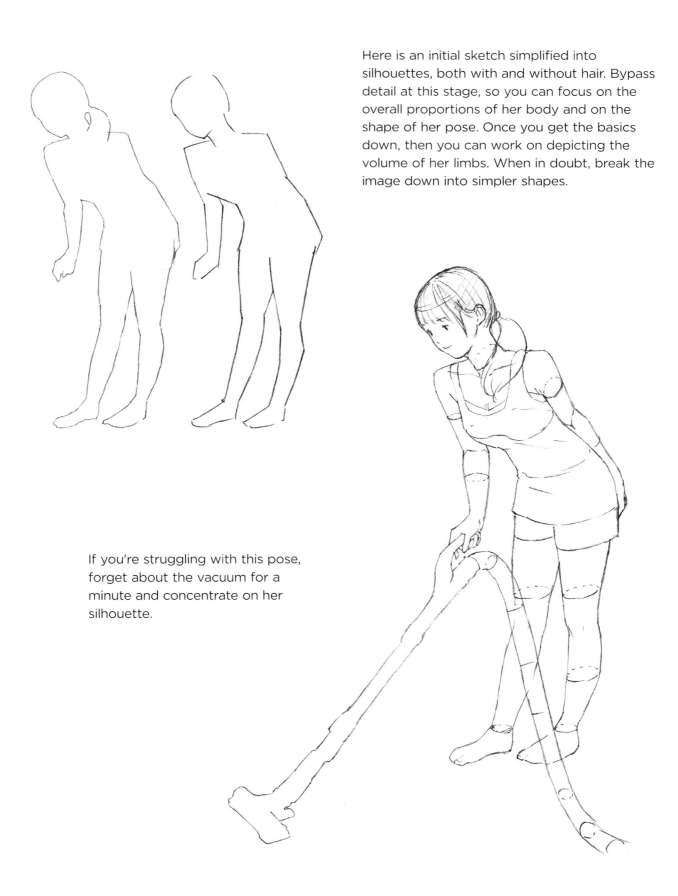

Here is an initial sketch simplified into silhouettes, both with and without hair. Bypass detail at this stage, so you can focus on the overall proportions of her body and on the shape of her pose. Once you get the basics down, then you can work on depicting the volume of her limbs. When in doubt, break the image down into simpler shapes.

If you're struggling with this pose, forget about the vacuum for a minute and concentrate on her silhouette.

3.6 Lifting Objects

Here, our model picks up a light package without any trouble. How can you tell it doesn't weigh much? Look closely at where her center of gravity falls during each step. Observe the tilt of her waist as she crouches to lift up the box and her mostly straight posture as she stands and holds it against her stomach. The weight of the box doesn't offer her much resistance at all!

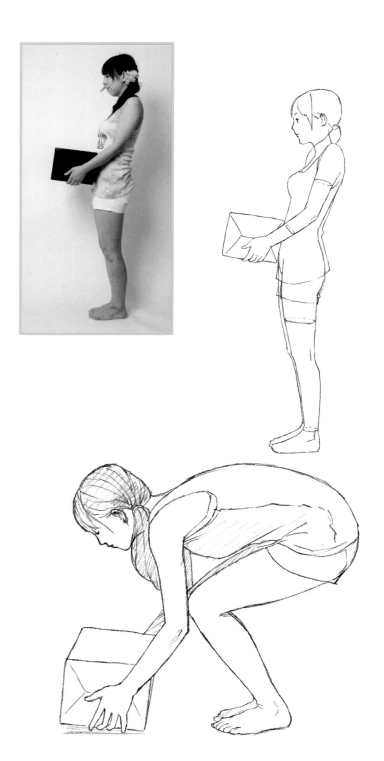

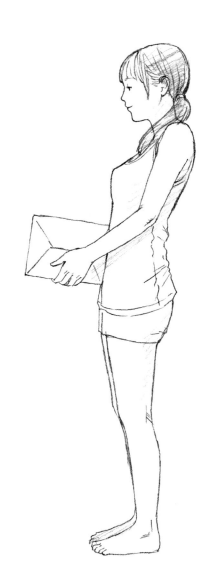

Once again, we see less motion from the front, but there's much more foreshortening in effect from her fingertips to to her toes. Pay attention to the roundness of her arms and legs in 3-D space. If you're finding it difficult to locate her center of gravity and understand how she's balancing the weight of the box, break her down into a silhouette and reanalyze the pose.

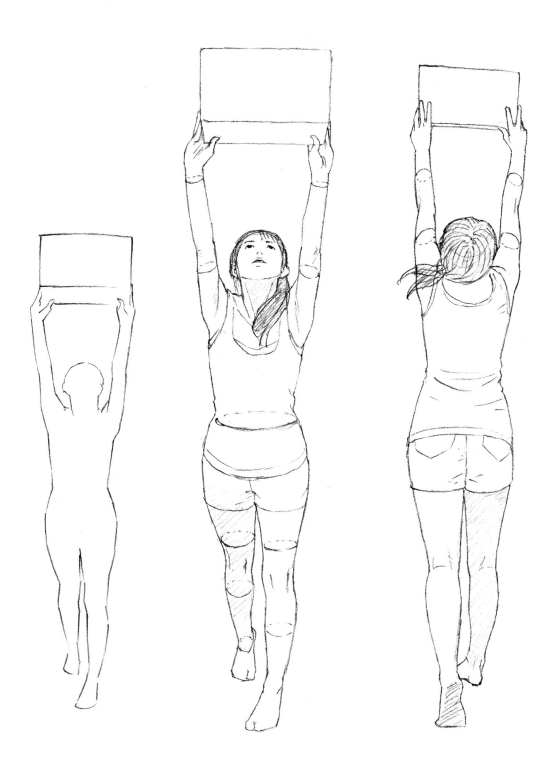

Wiping a Table

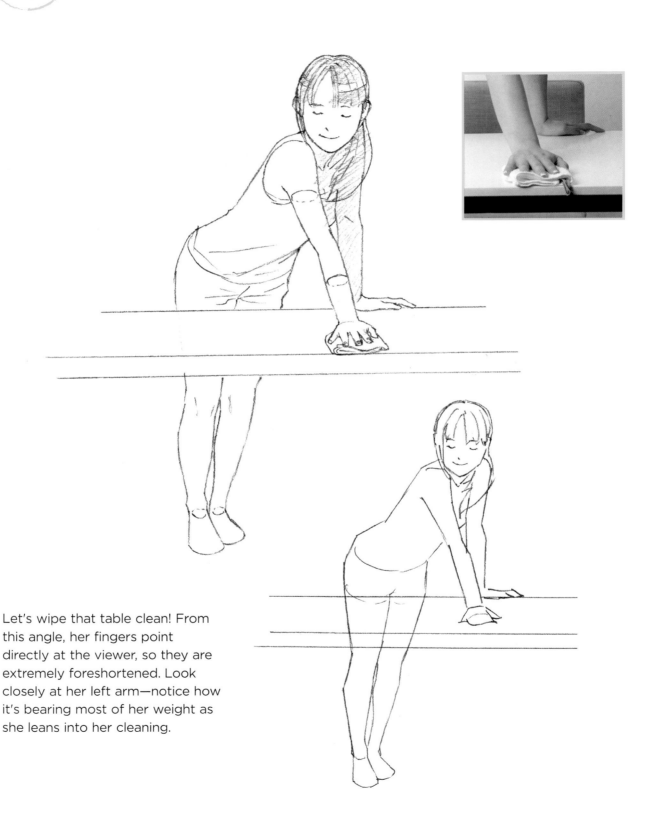

Let's wipe that table clean! From this angle, her fingers point directly at the viewer, so they are extremely foreshortened. Look closely at her left arm—notice how it's bearing most of her weight as she leans into her cleaning.

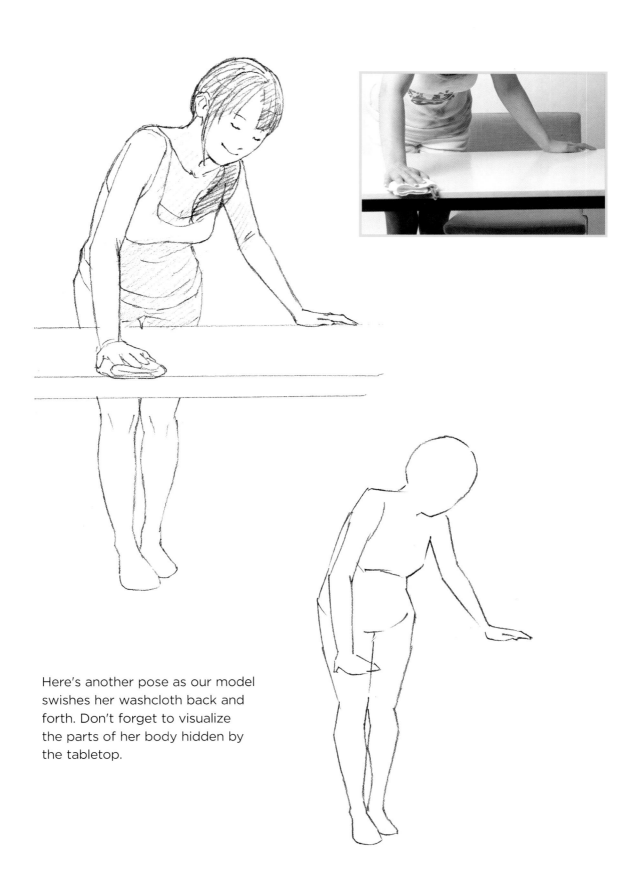

Here's another pose as our model swishes her washcloth back and forth. Don't forget to visualize the parts of her body hidden by the tabletop.

Cooling Off

Mmm, what a nice breeze after all that work! Make sure to show the movement of her hair and of any loose articles of clothing when the fan is on versus when it's off.

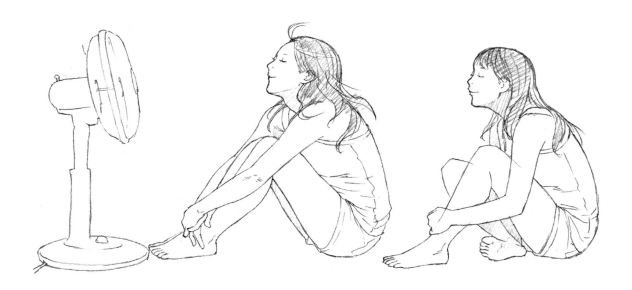

Let's change the settings on the fan. If you draw this pose straight from your imagination, you might miss realistic details like the distance she sits from the fan, the way she presses its buttons with one finger and how she supports some of her weight with her left hand.

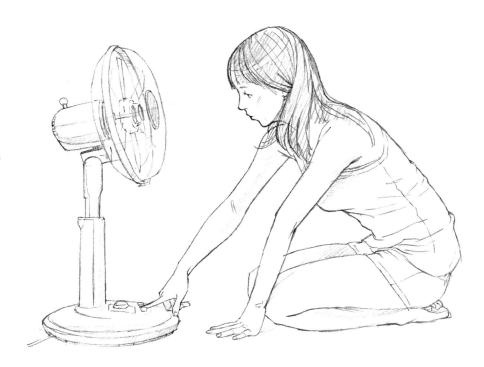

Here's an angle from above, like we're standing nearby and staring down at her. Watch out for where you place her heels in relation to her body, and make sure they're on the same plane as her hips.

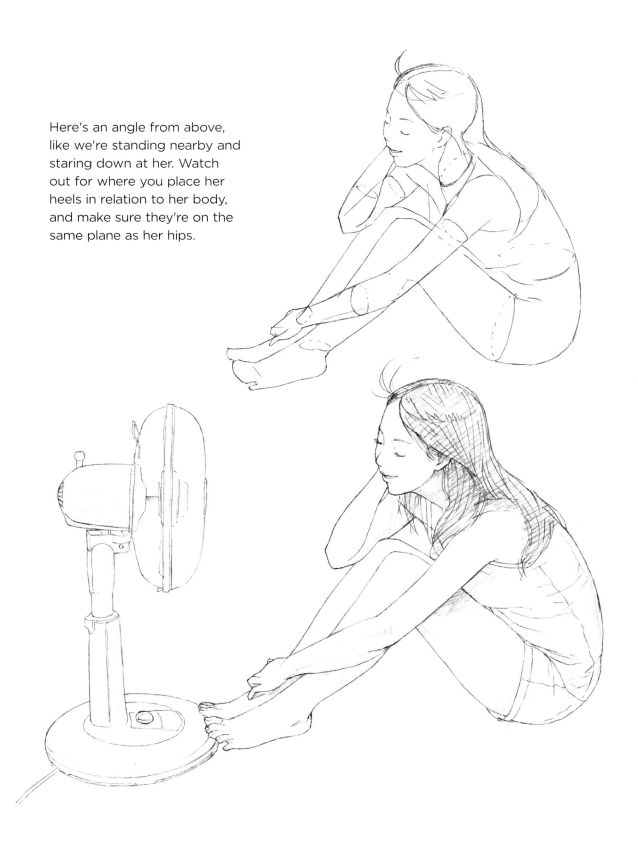

Opening Doors

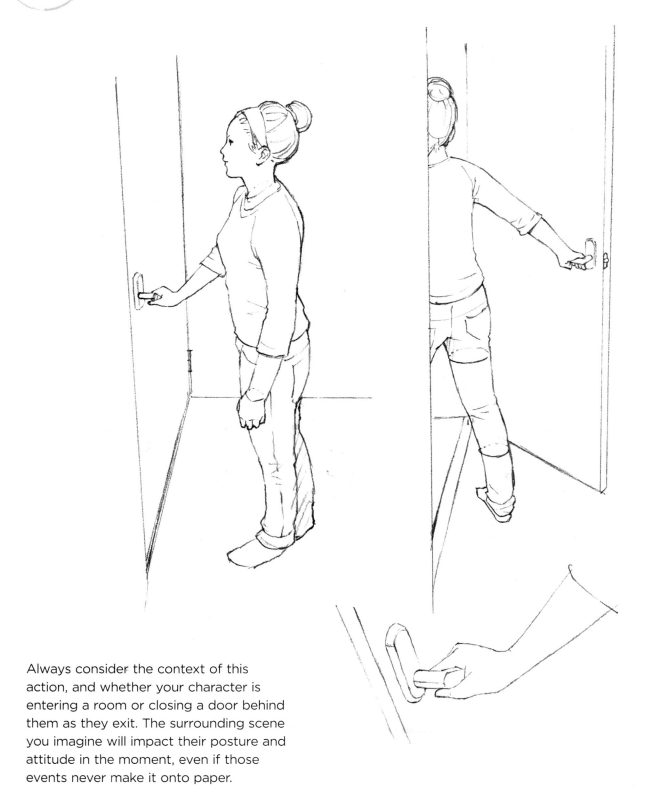

Always consider the context of this action, and whether your character is entering a room or closing a door behind them as they exit. The surrounding scene you imagine will impact their posture and attitude in the moment, even if those events never make it onto paper.

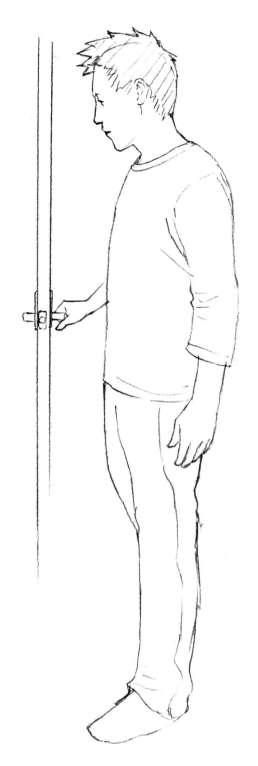

As you design and draw a larger cast of characters, pay attention to how their differing heights affect the way they interact with their environment. This model is taller than the girl on the previous page, so the door handle will look comparably lower for him.

Opening Windows

Let's get a breath of fresh air! Modern apartments, old-fashioned houses, office buildings and schools each have their own style of window made with different materials. So always try to be specific in your illustrations, and use a reference to make sure you're incorporating the right kind of details for your chosen environment.

Resting

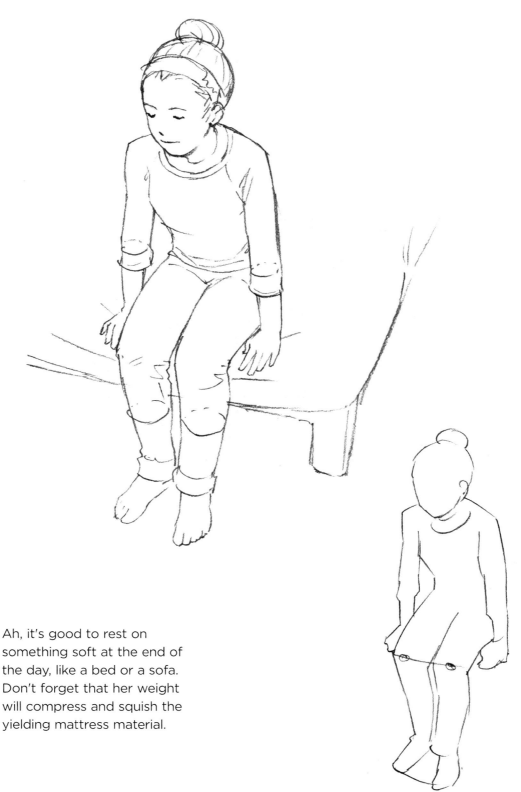

Ah, it's good to rest on something soft at the end of the day, like a bed or a sofa. Don't forget that her weight will compress and squish the yielding mattress material.

Around the House: Reference Guide for Drawing Hands

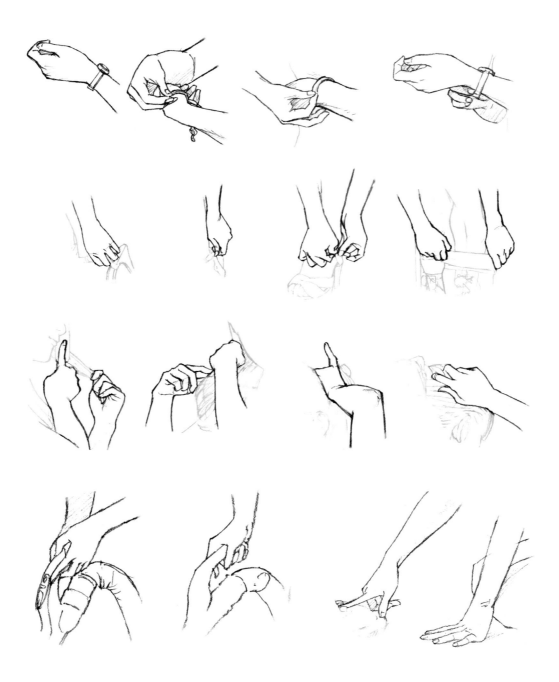

When drawing hands, try to maintain the movement of the entire body through the fingertips. A good rule of thumb is to work in this order: Complete pose (body), specific details (hands), then overall balance (full composition).

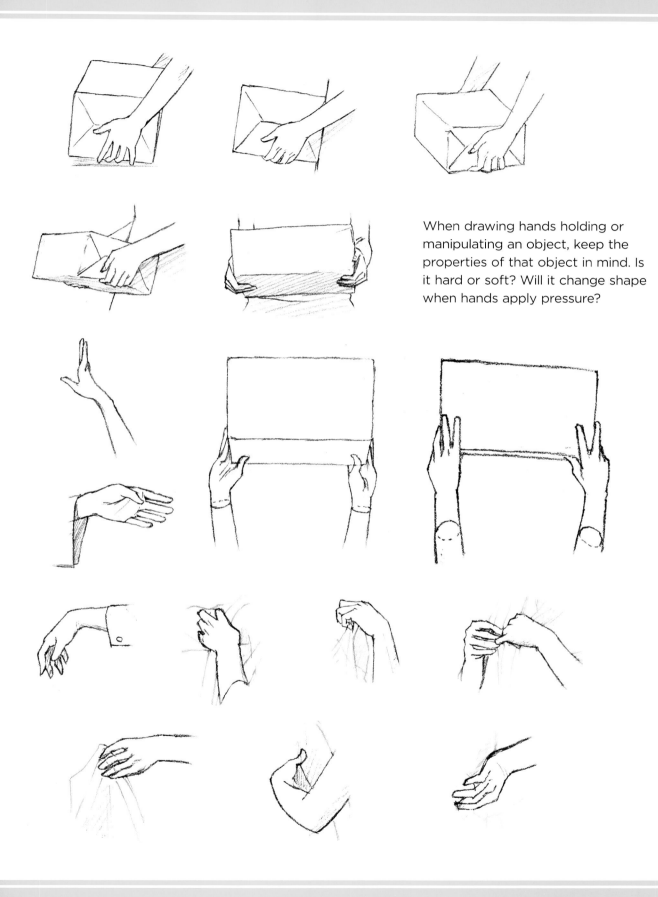

When drawing hands holding or manipulating an object, keep the properties of that object in mind. Is it hard or soft? Will it change shape when hands apply pressure?

Drawing Cartoons

Q: What is your advice for transforming a photo of a real person into a cartoon character?

A: Even if you are drawing a cartoon character that is only 2-3 heads tall, you are still drawing a human being. In order to make your cartoon believable, you should aim to preserve some of the realism and humanity of the person in your reference photo.

Q: What techniques do you use to achieve this goal?

A: My cartooning method is to either exaggerate or omit the original elements of the human body. Depending on the artist, you can find a lot of characters with almost the same exact body shape that only differ from each other in their faces or hair styles, but if I'm drawing a bunch of different characters I want the reader to be able to identify them each at a glance. All that aside, when I've worked with computer graphics teams from outside Japan, they'd tell me "Japanese characters don't have noses and look really weird." For me it was the exact opposite—animated or game characters from countries outside Japan look thick and heavy to me—so it all might depend on your nationality or familiarity with a style.

Q: When you're stylizing a photo reference, do you still draw the cartoon character three-dimensionally?

A: The basic positioning of each body part in a particular pose doesn't change much at any head height, so I still use 3-D shapes where I can. But at the same time, omitting details from the photo like clothing wrinkles or even fingers can be a very useful technique. You can choose the method of stylization depending on what you want to express. If you want to prioritize cuteness, you emphasize things like eyes, and if you want to prioritize action, you can emphasize the body parts that show the most dramatic movement, like arms and legs. But in some cases, clarity becomes necessary at the expense of coolness or cuteness, so it's good to determine what you're going for in advance and move confidently in that direction.

Q: Which angles in photography, like wide-angle or telephoto lens, best fit cartoony characters?

A: You can change the angle on your characters depending on their personality and the overall effect you're going for with your illustration. If you want a dynamic scene, try a wide-angle lens to show more of the background that you can draw in perspective. For example, video game packaging often has dramatic poses like a character punching their fist straight at the camera. But if you simply want to focus on cuteness, just use a regular lens.

Chapter 4

At Work & At Play

Let's get creative! In this chapter, we'll explore drawing people engaged in work-related activities, like reading, using a computer, writing and taking photos. Then, we'll kick back and relax with leisure activities, such as playing video games and exercising.

These kind of scenes are incredibly common—especially working on a computer—so let's make sure they look natural to our audience.

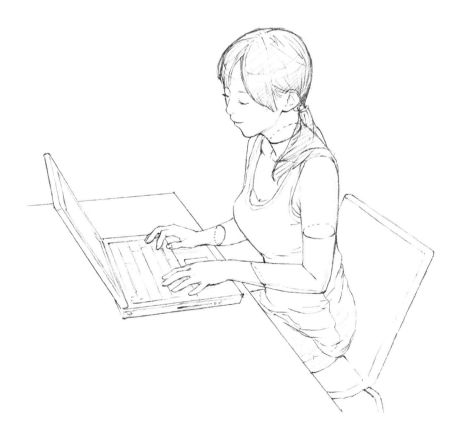

4.1 Thinking

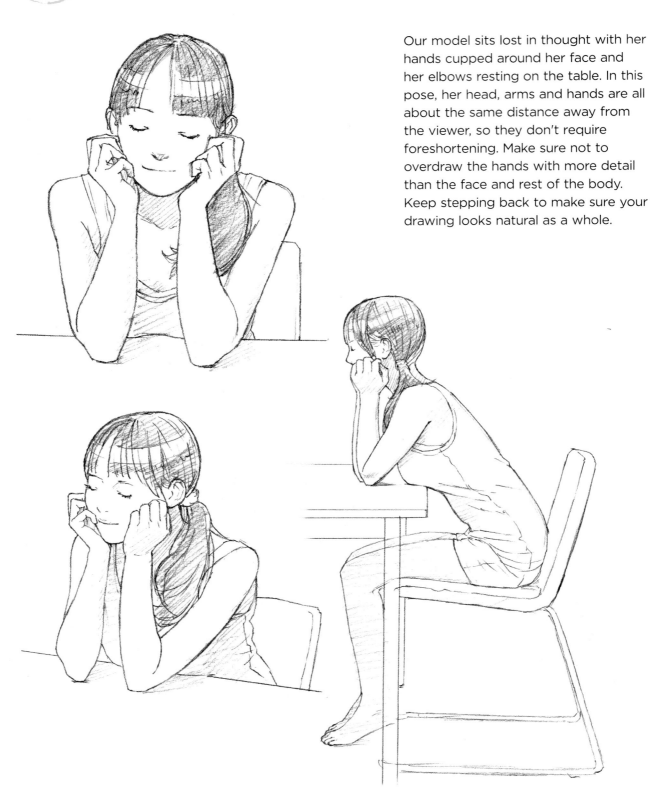

Our model sits lost in thought with her hands cupped around her face and her elbows resting on the table. In this pose, her head, arms and hands are all about the same distance away from the viewer, so they don't require foreshortening. Make sure not to overdraw the hands with more detail than the face and rest of the body. Keep stepping back to make sure your drawing looks natural as a whole.

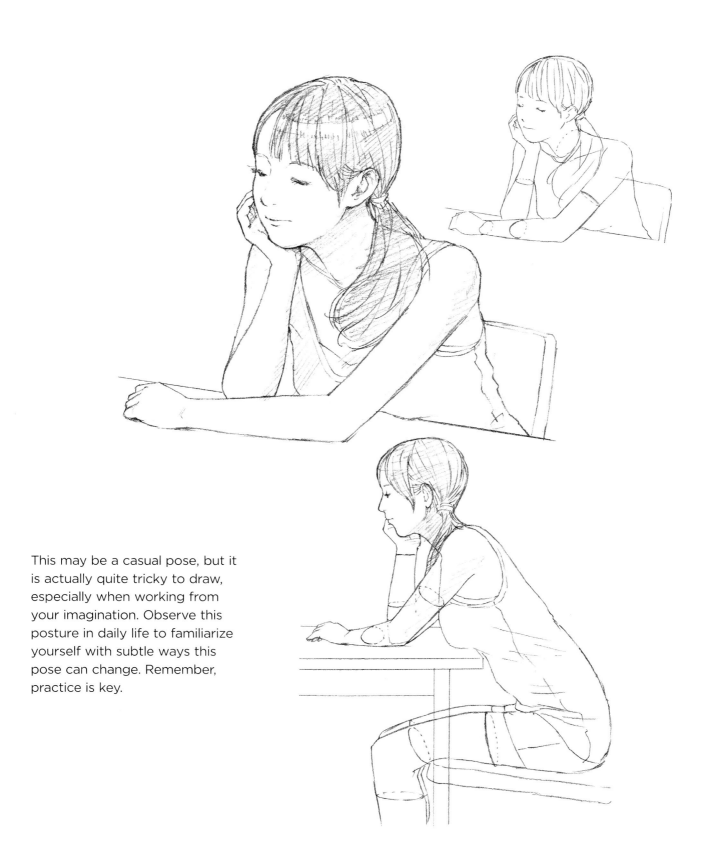

This may be a casual pose, but it is actually quite tricky to draw, especially when working from your imagination. Observe this posture in daily life to familiarize yourself with subtle ways this pose can change. Remember, practice is key.

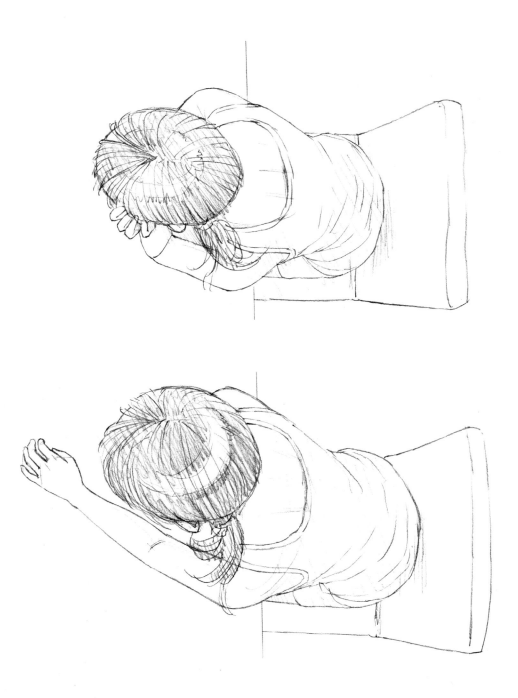

These thinking poses are drawn from an overhead
view. Don't forget to draw the back of her chair in
foreshortened perspective!

Let's view the same pose from several different angles. From these vantage points we can clearly see that the screen is tilted away from her.

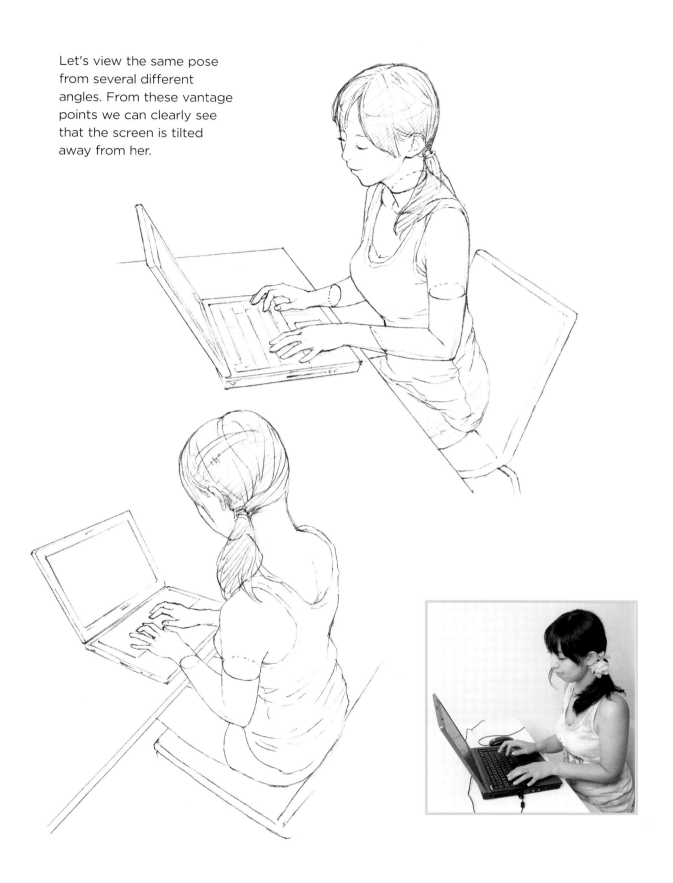

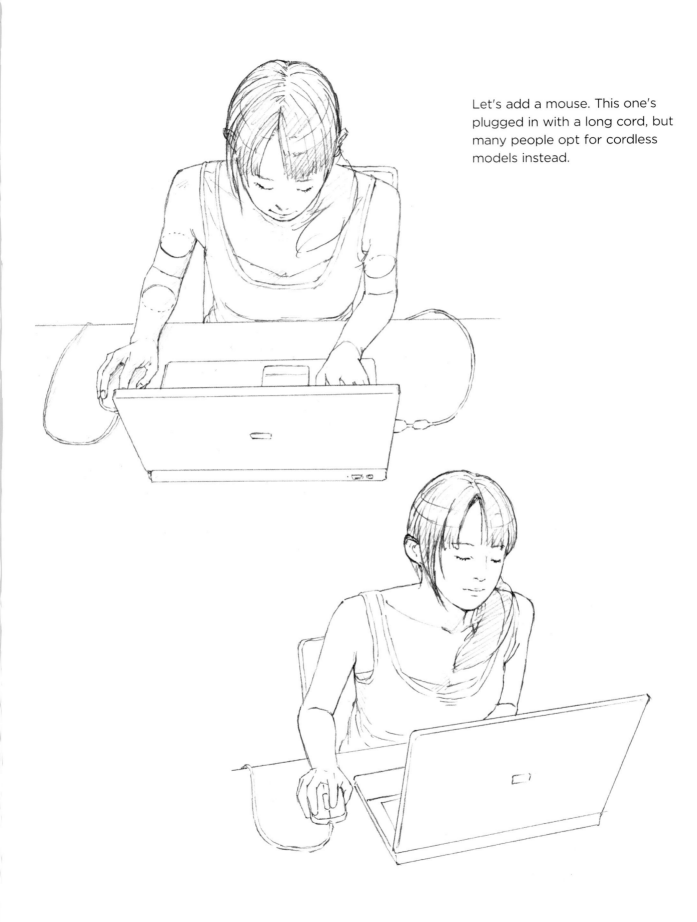

Let's add a mouse. This one's plugged in with a long cord, but many people opt for cordless models instead.

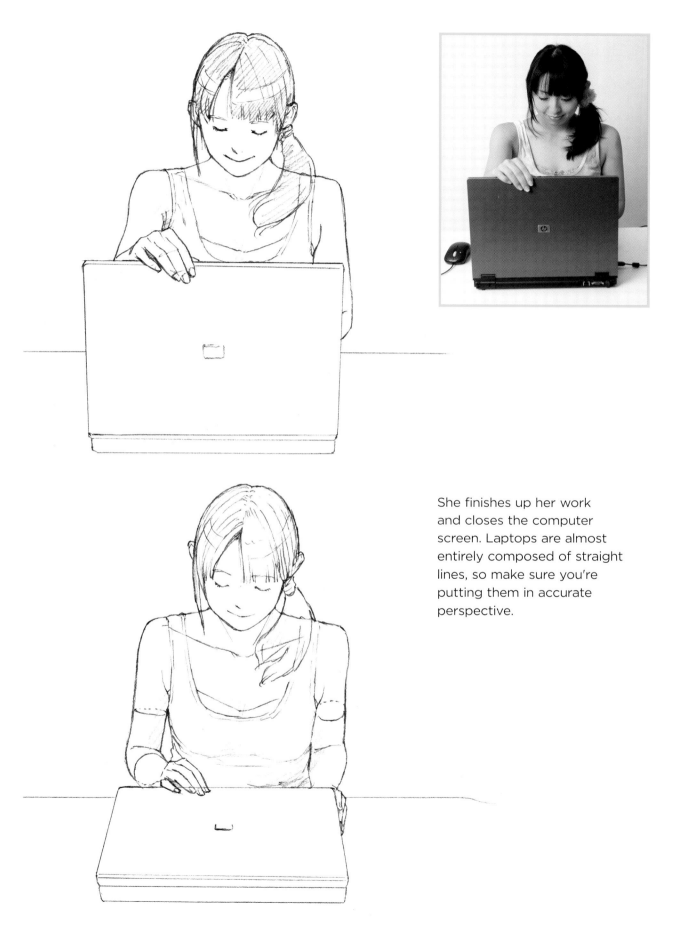

She finishes up her work and closes the computer screen. Laptops are almost entirely composed of straight lines, so make sure you're putting them in accurate perspective.

4.7 Drawing & Writing

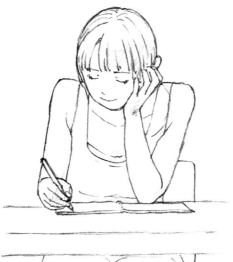

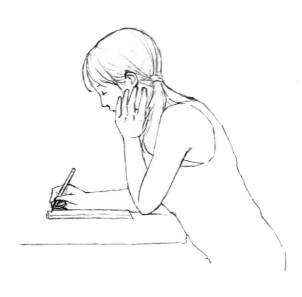

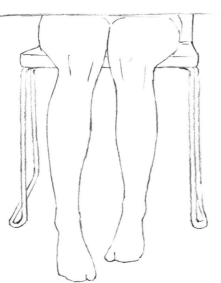

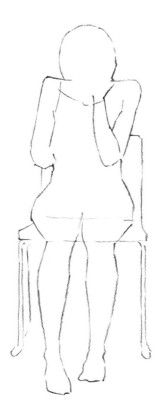

Is she writing or drawing? Is she working on something for a client, for a friend or just for herself? Is she at home, at an office or in a public space? Getting specific about the situation will help you draw more freely and naturally. Consider these possible scenes and give them a try:

- Studying under pressure
- Taking the minutes for a meeting
- Writing a letter to a friend

The posture will vary greatly in all these scenes, even if you're drawing the same character performing these tasks.

Here are some close-ups of her hand as she works. Start off with a rough silhouette that outlines the thumb and the shape of the combined fingers. Then, add in depth and break the silhouette down into individual fingers.

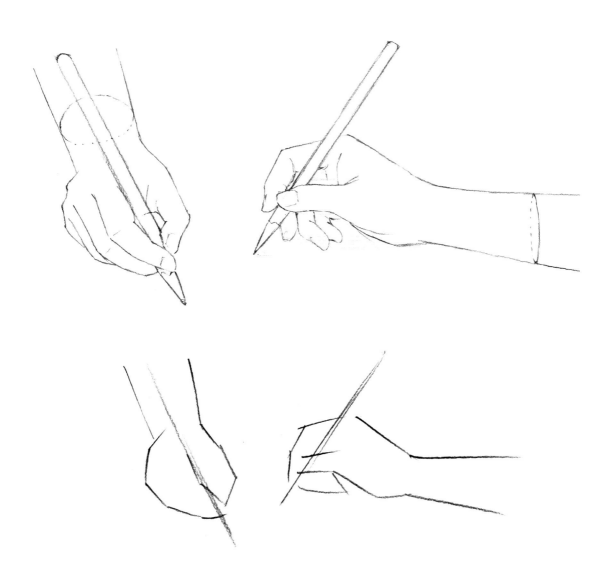

Taking Photos

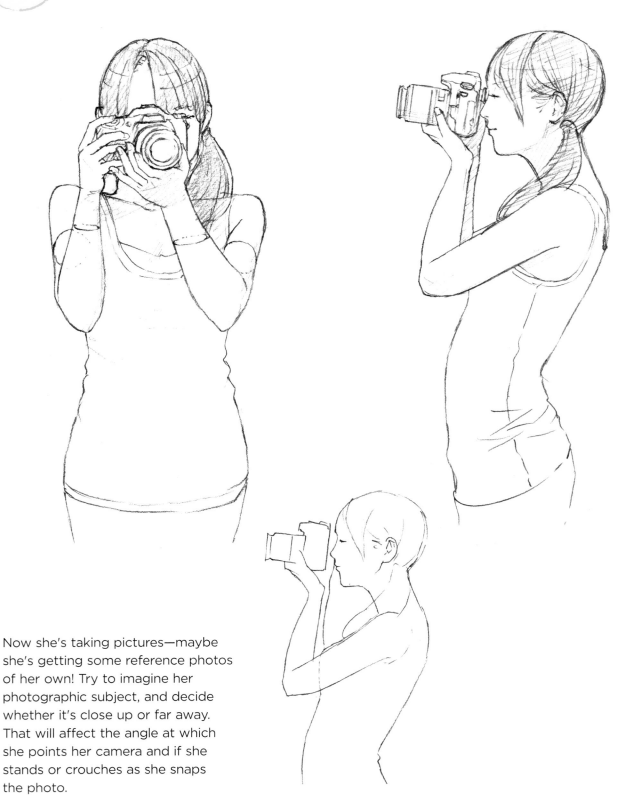

Now she's taking pictures—maybe she's getting some reference photos of her own! Try to imagine her photographic subject, and decide whether it's close up or far away. That will affect the angle at which she points her camera and if she stands or crouches as she snaps the photo.

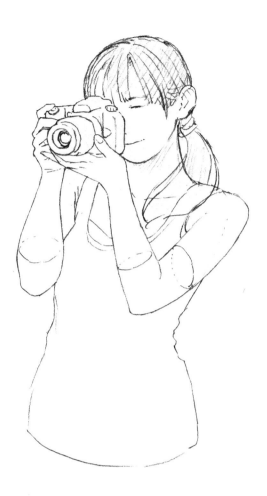

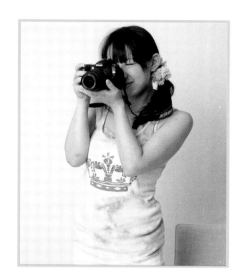

We continue to rotate our vantage point around our model. Observe how both of her hands have a job of their own. Her left hand supports the camera and turns the aperture settings while her right hand manipulates the buttons on the top.

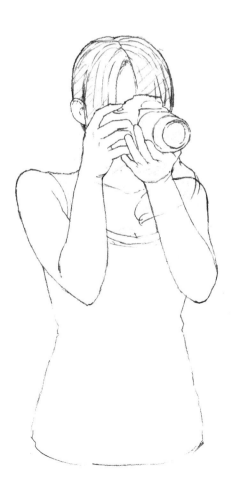

Now she's taking a photo of
something high above her,
like a building or a bird.

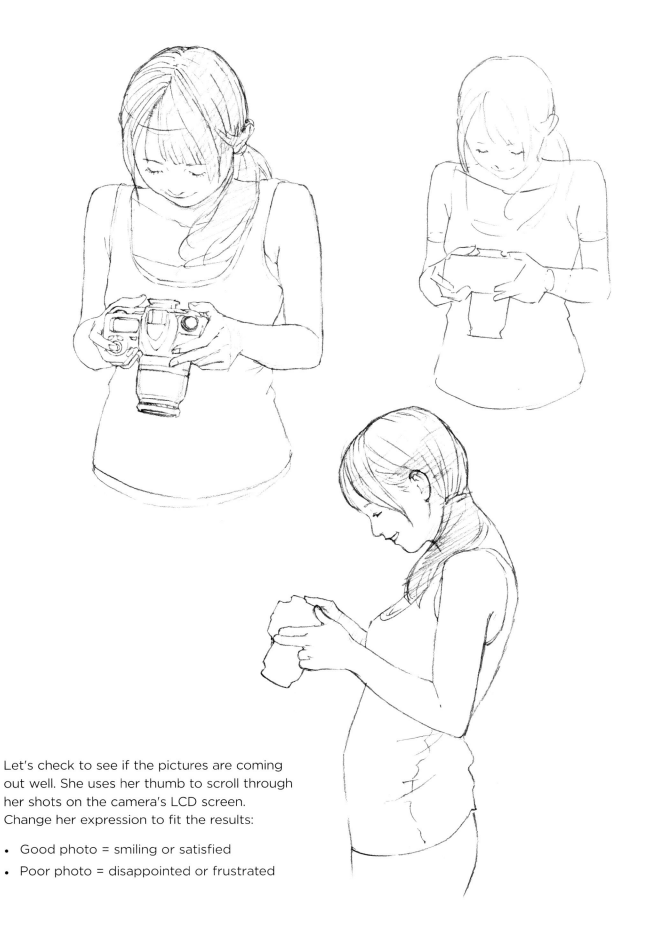

Let's check to see if the pictures are coming
out well. She uses her thumb to scroll through
her shots on the camera's LCD screen.
Change her expression to fit the results:

- Good photo = smiling or satisfied
- Poor photo = disappointed or frustrated

Assorted Work Poses

Our model sits cross-legged on the floor and rests his elbows on a low table.

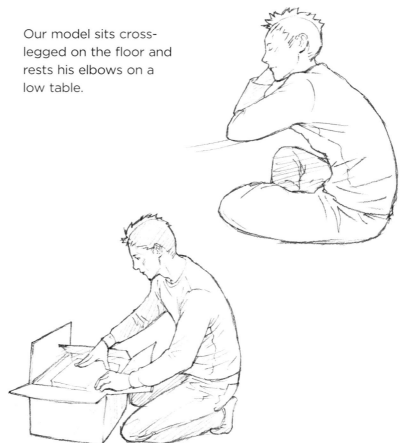

Now he kneels to open a cardboard box and unpack something.

Here, he sits on the floor as he uses a laptop.

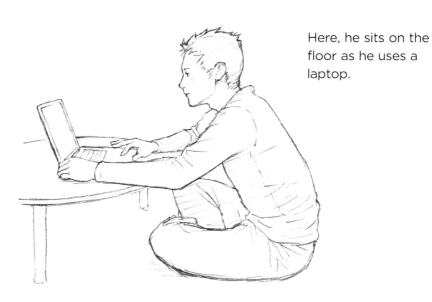

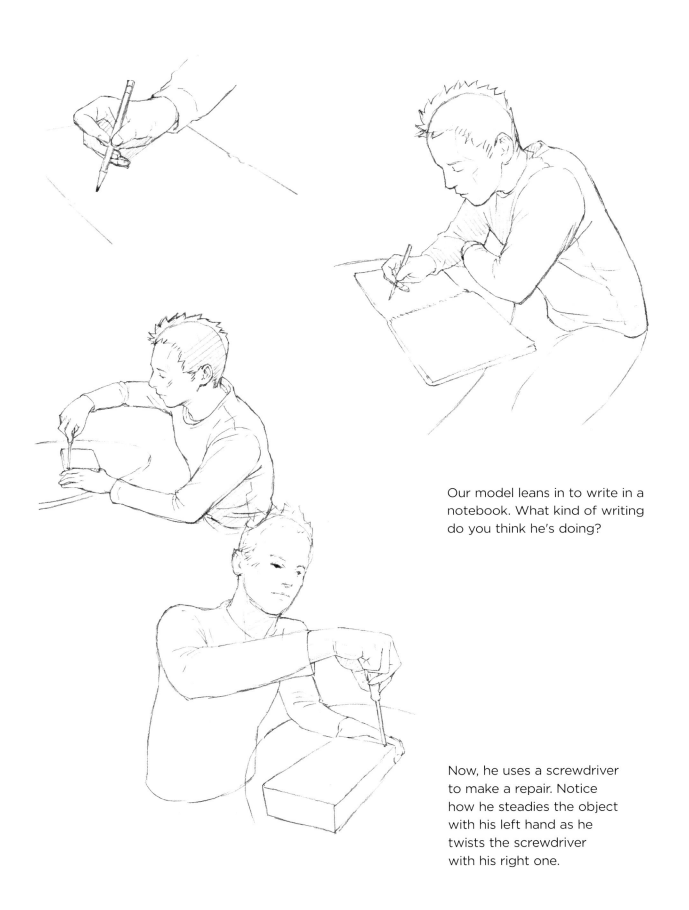

Our model leans in to write in a notebook. What kind of writing do you think he's doing?

Now, he uses a screwdriver to make a repair. Notice how he steadies the object with his left hand as he twists the screwdriver with his right one.

4.10 *Stretching*

Our model works out tension in her hips, thighs and shoulders with this seated pose. She places the soles of her feet together and bends sharply at the waist, pushing her knees downward. Notice how her ponytail obeys gravity, fanning out and falling forward as she tilts her head down. Sketch in a grid beneath her to help understand which parts of her body are pressed against the floor and where they make contact.

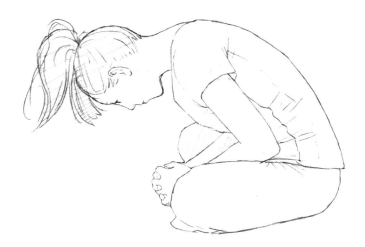

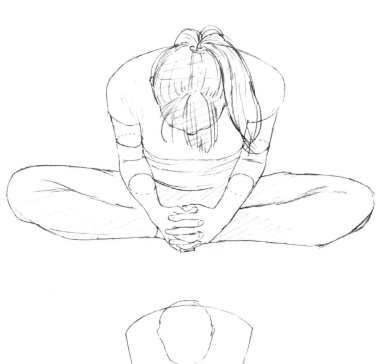

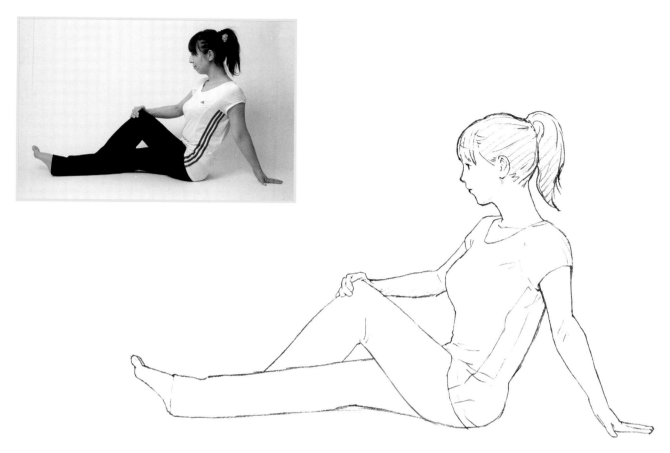

Now she twists her waist and upper body by crossing her left leg over the right. Pay attention to how she pushes her knee with her right hand to increase the angle of her twist.

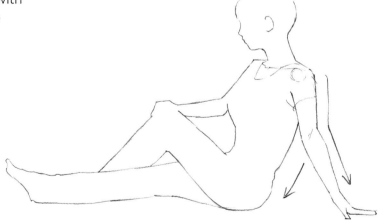

Check out the different angles of her supporting left arm. Since she's physically fit, her joints are quite flexible and her elbow braces her weight at a dramatic angle.

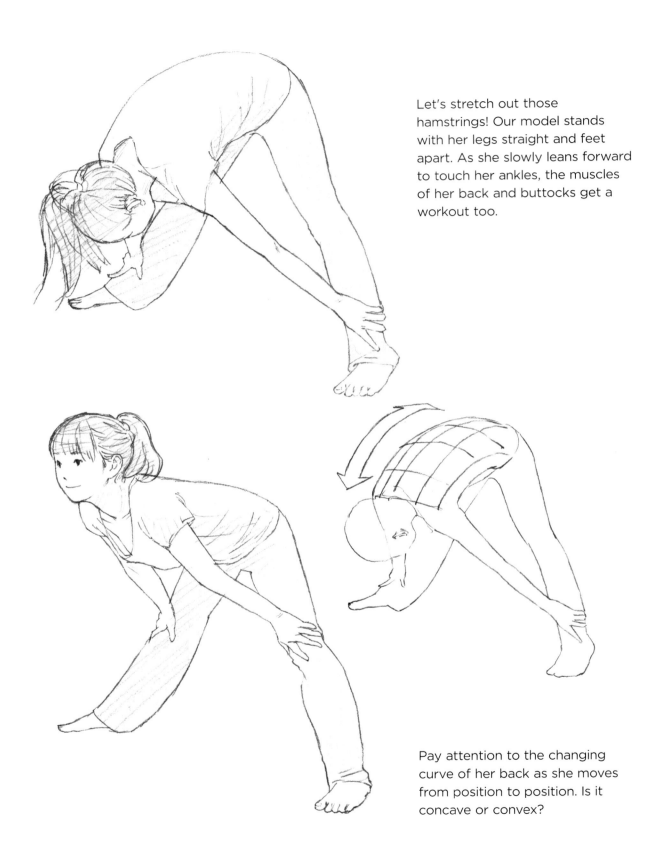

Let's stretch out those hamstrings! Our model stands with her legs straight and feet apart. As she slowly leans forward to touch her ankles, the muscles of her back and buttocks get a workout too.

Pay attention to the changing curve of her back as she moves from position to position. Is it concave or convex?

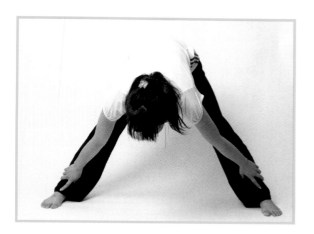

Here is the same pose from the front.

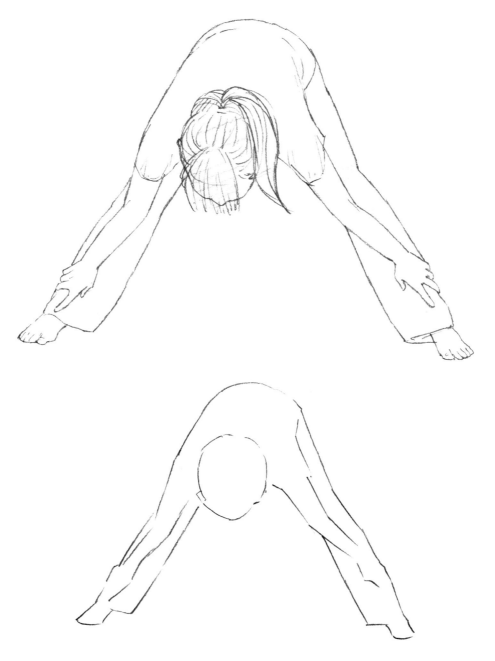

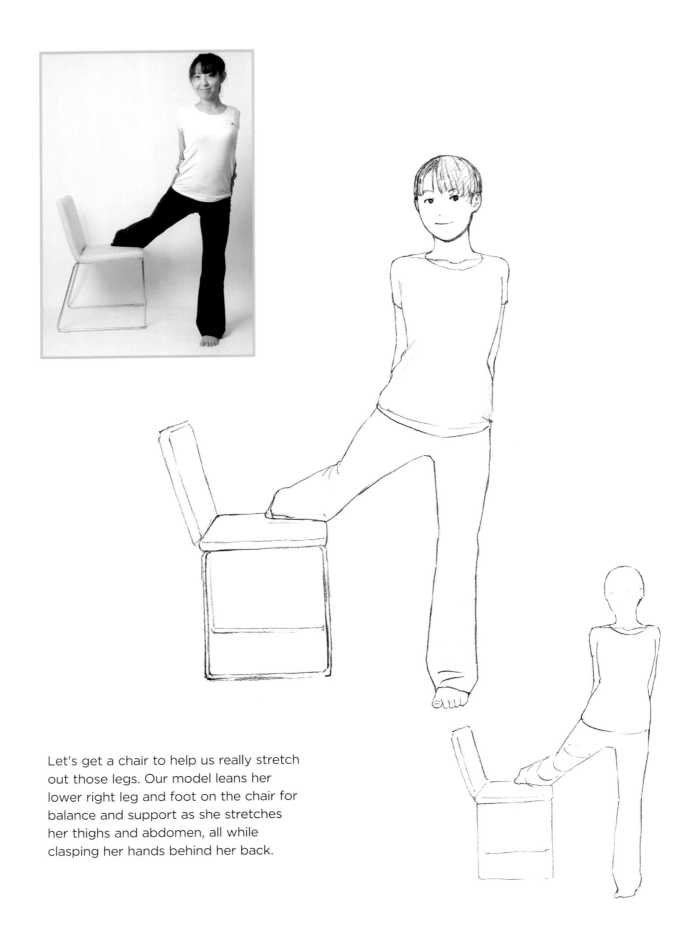

Let's get a chair to help us really stretch out those legs. Our model leans her lower right leg and foot on the chair for balance and support as she stretches her thighs and abdomen, all while clasping her hands behind her back.

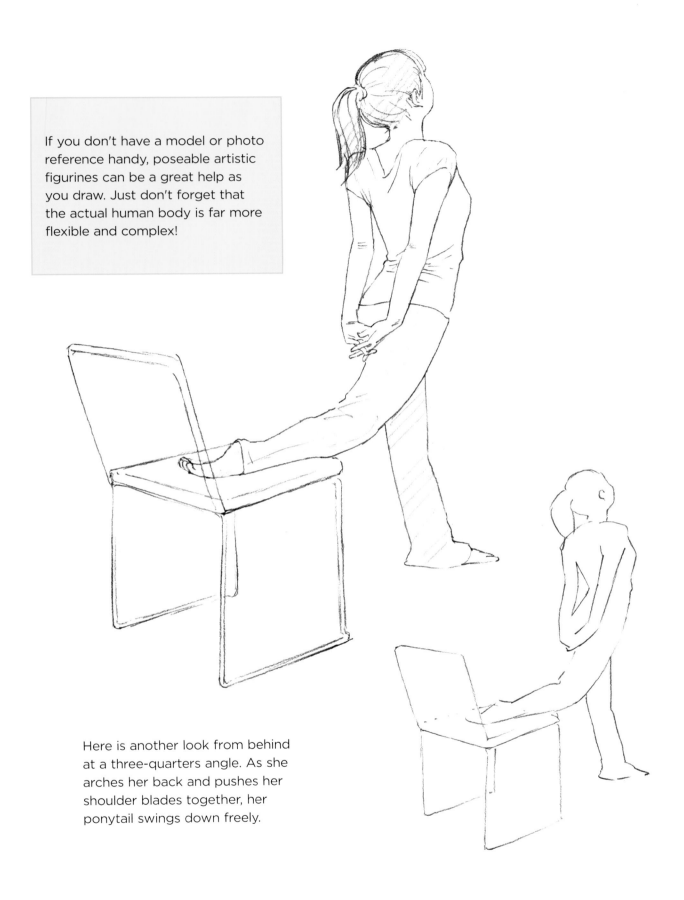

If you don't have a model or photo reference handy, poseable artistic figurines can be a great help as you draw. Just don't forget that the actual human body is far more flexible and complex!

Here is another look from behind at a three-quarters angle. As she arches her back and pushes her shoulder blades together, her ponytail swings down freely.

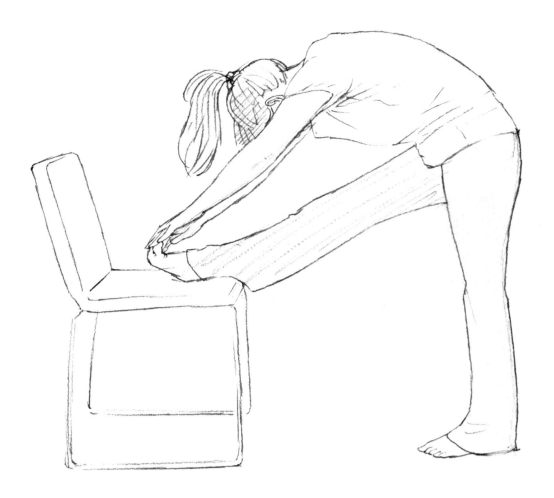

Now she uses the chair to touch her toes. From the side, we can easily read the position of each limb in her silhouette. Pay attention to the placement of her joints as you move forward in your sketch.

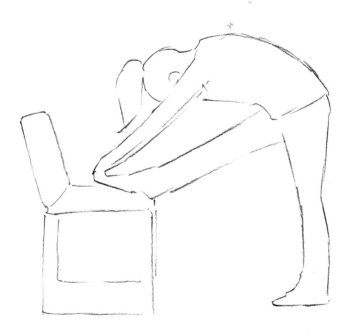

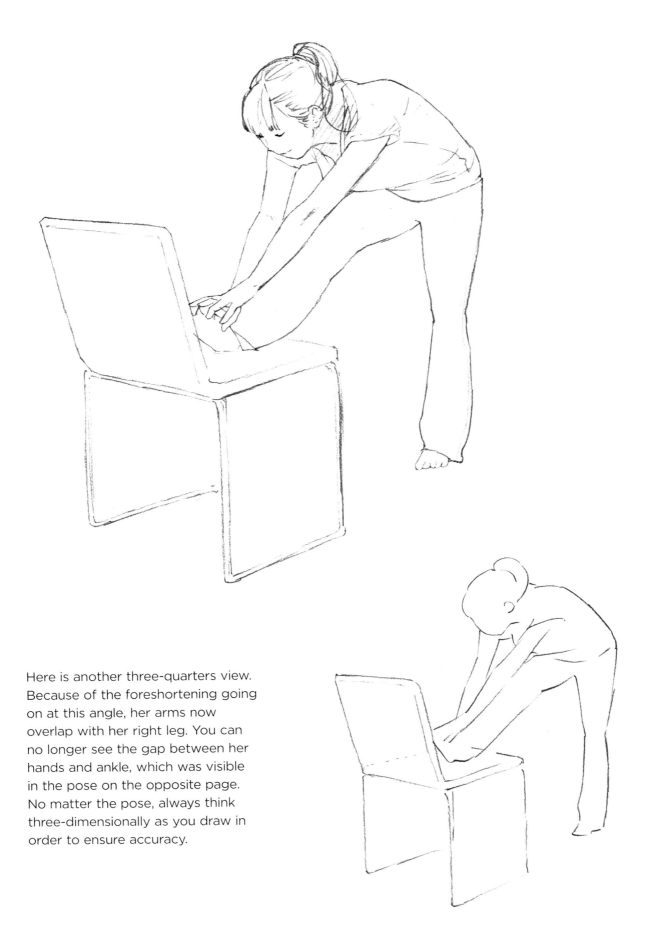

Here is another three-quarters view. Because of the foreshortening going on at this angle, her arms now overlap with her right leg. You can no longer see the gap between her hands and ankle, which was visible in the pose on the opposite page. No matter the pose, always think three-dimensionally as you draw in order to ensure accuracy.

At Work & At Play: Reference Guide for Drawing Hands

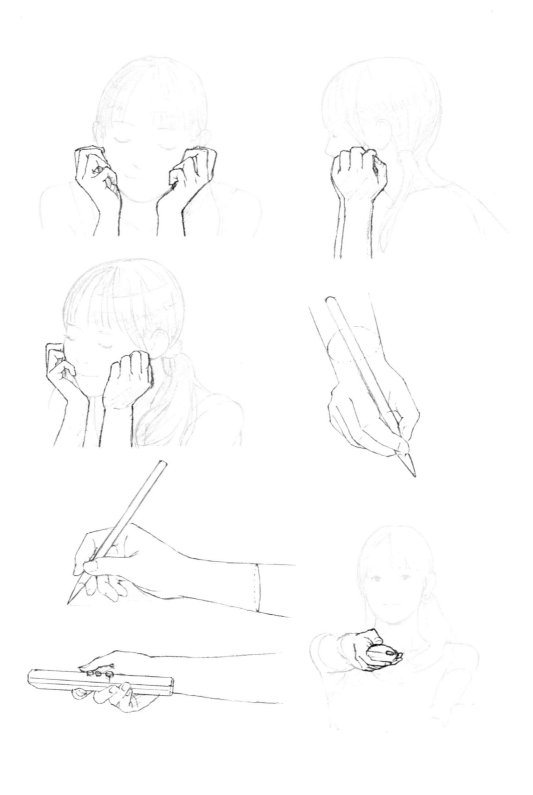

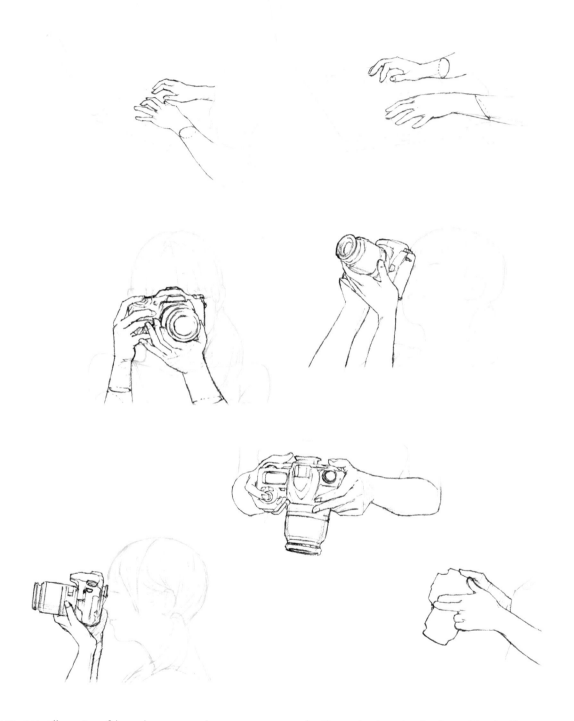

Here are all sorts of hand poses using cameras and other electronic devices. Typically one hand or the palms of both hands support the object, while the fingers go to work on the buttons or keys.

Deciding When a Project Is Finished

Q: How do you decide when a drawing is finished?

A: As a professional illustrator whose work will go out into the world as a product, I base my decision on the drawing's commercial appeal. I ask myself, would I want to buy this product if I saw it in a store? Sometimes, I'll even print my illustration out and mount it on a game box or the cover of a gaming magazine in order to compare it to published characters.

Although I always draw on A4-sized paper, the illustration may be used at many different sizes. I'll print the image out on a smaller scale to make sure I can still recognize the character.

When you've been working on a piece for a long time, your eyes grow familiar with the drawing and it's hard look at it objectively. As a final test, I'll walk away from the drawing and let it sit overnight. If I look at it with fresh eyes and am satisfied with what I see, I know the drawing is finished.

Q: If you're working for long hours, you can lose your objectivity about the drawing?

A: Yes, you can become oblivious to the awkward or overdrawn parts.

Q: So you can find the "off" parts easily after you let your drawings sit overnight?

A: Yes. This happens to me all the time, especially with overdrawn, strained faces or hands that are too small. I'll look at the drawing the next day and immediately notice what's wrong.

Q: Have you ever noticed that there are some manga artists whose drawings are better at the end of the story than at the beginning?

A: The more frequently you draw a character, the better you become. This is especially true with tricky poses and angles. Some artists perform well under pressure, so their work may improve when they're under a deadline.

Q: So artists' skills grow as they master drawing their characters?

A: Yes, if you don't get lazy or fall into a rut. Make sure you don't avoid the harder poses and angles, or else you will never grow as an artist.

Q: The reader's impression of the work is important too, right?

A: Yes. You might need to change certain aspects of your illustration style in order to appeal to a broader variety of readers. Illustrators can get hurt when their work is rejected, because so many of us are fragile. But if you really want to improve as an artist, it's important to show your work to lots of people and get their objective opinions.

Cooling Off *(Original drawings on pages 118-119)*

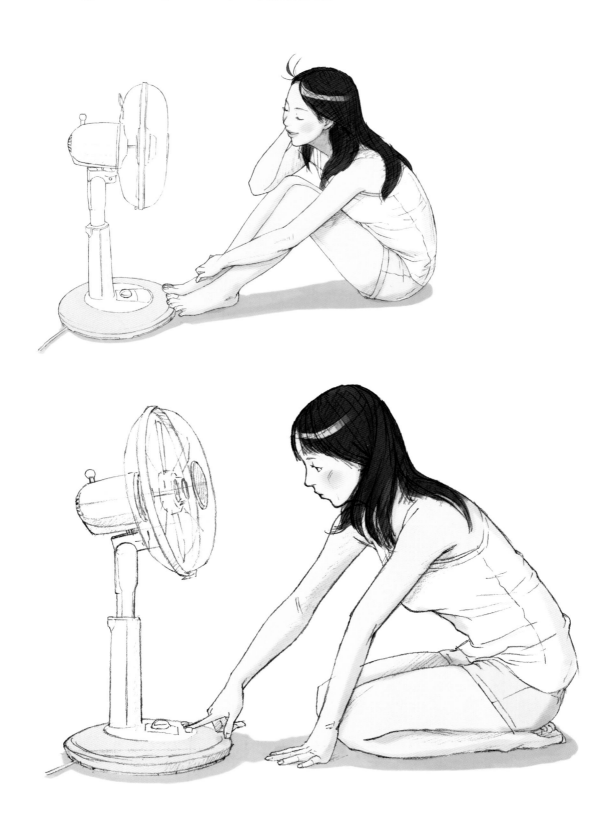

Thinking *(Original drawings on page 128)*

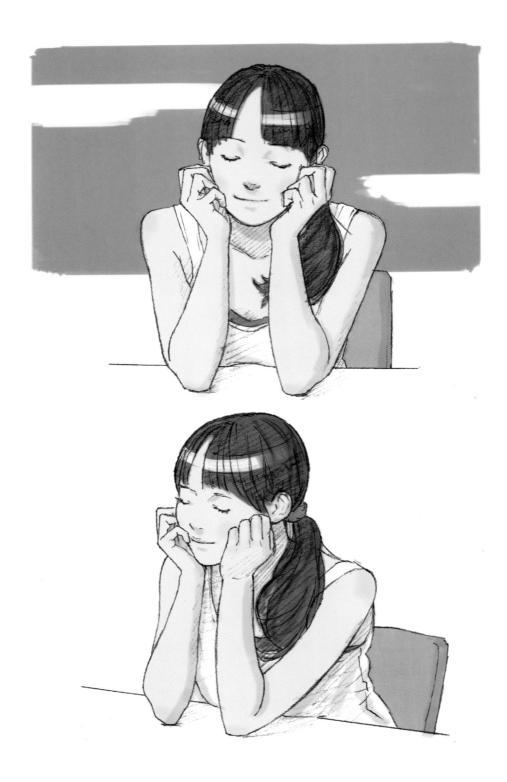